The Campus History Series

GEORGIA SOUTHERN UNIVERSITY

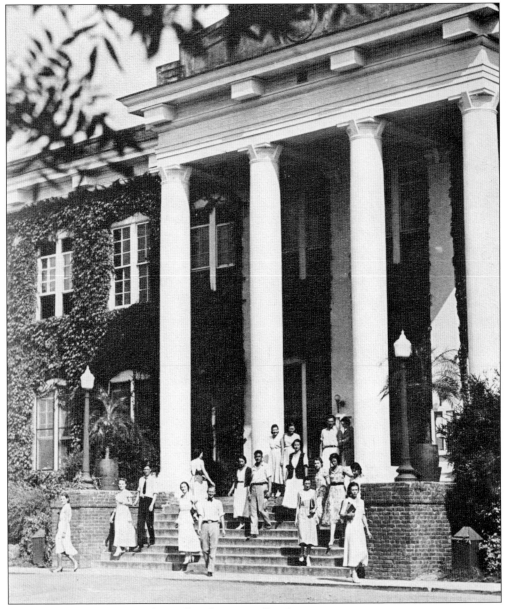

Pictured here in 1933 are the Halls of Ivy at Collegeboro.

ON THE FRONT COVER: The athletic association's new 20-passenger bus, trimmed in blue, white, and silver, began service in April 1934. Students were excited when the bus arrived but became leery of the vehicle after it broke down regularly. In the fall of 1935, an engine problem forced the football team to hitchhike back to Collegeboro from Boone, North Carolina, after enduring a frustrating tie with Appalachian State.

COVER BACKGROUND: The original Anderson Hall, built by students in 1912, was a dining and residence hall until an expanding campus caused its removal in 1959. Because the building honored J.R. Anderson, the founding chairman of the board of trustees, the college officially changed the name of the first women's dormitory from East Hall to Anderson Hall.

The Campus History Series

GEORGIA SOUTHERN UNIVERSITY

Delma E. and Beverly B. Presley
with a Foreword by Brent W. Tharp, PhD

ARCADIA
PUBLISHING

Copyright © 2013 by Delma E. and Beverly B. Presley
ISBN 978-1-4671-1040-2

Published by Arcadia Publishing
Charleston, South Carolina

Printed in the United States of America

Library of Congress Catalog Card Number: 2013946954

For all general information, please contact Arcadia Publishing:
Telephone 843-853-2070
Fax 843-853-0044
E-mail sales@arcadiapublishing.com
For customer service and orders:
Toll-Free 1-888-313-2665

Visit us on the Internet at www.arcadiapublishing.com

In Memory Of Dr. Jack Nelson Averitt
1922–2007
professor emeritus
and dean emeritus of the
Jack N. Averitt College of Graduate Studies

CONTENTS

FOREWORD

In 1900, just six years prior to the founding of Georgia Southern University, the Eastman Kodak Company introduced with wild success the inexpensive, point-and-shoot Brownie camera, giving ordinary people the ability to escape the formal photograph studio and capture candid moments of personal events in out-of-the-way places. The advent of popular photography ensured that even as its first buildings were under construction, Georgia Southern's history was documented from the very beginning. This book represents a well-curated collection of those photographic moments that tell the fascinating story of the school's growth from, in the authors' words, "an aspiration set in a pine forest" to its current status as a major research university in just over 100 years.

This volume is rooted firmly in a place and time. The thoroughly researched text tells the unvarnished story of Georgia Southern's development, which has not been without controversy and, at times, challenges. Dr. Delma "Del" Presley's writing interprets these events with insight and honesty, helping readers truly understand this place. Unlike many of its sister A&M institutions and other schools established in early-20th-century Georgia, Georgia Southern University grew and thrived in spite of difficult social, economic, and political obstacles. The history of the people and the decisions that made this possible is inspiring, as well as truthful. Finally, the authors selected a unique archive of images that depicts the story of the people, facilities, and traditions that have made Georgia Southern University.

Del Presley is uniquely qualified to take on this task that he shares with his wife of 52 years, Beverly Bloodworth Presley. She has been a research partner and a travelling companion to archives and libraries. She is an in-house editor and more. She helped gather information and has planned the image flow for this volume of the Campus History series.

The Presleys moved to Georgia Southern University in 1969, shortly after Del received his doctorate from Emory University. He was a professor of English in 1982 when the university opened its museum. He held the position of museum director from 1982 until his retirement in 1999. He was a founding member of the Georgia Association of Museums and Galleries and the Bulloch County Historical Society. Beverly received her bachelor of arts degree from Mercer University in 1960 and married Del, whom she met at college, a year later. They have three children and four grandchildren.

Throughout his career, Del has chronicled the history and culture of south Georgia, Bulloch County, Statesboro, and Georgia Southern University specifically. Mentors, friends, and colleagues have given him unprecedented access to archives, personal papers, memories, and collections to document this story as no one else could. His dogged determination, long and cherished personal attachment to Georgia Southern University, and dedication to the historian's craft make this work important. The Presleys can be proud of this moving account of an academic institution that continues to make history.

—Brent Tharp, PhD, Director
Georgia Southern University Museum

ACKNOWLEDGMENTS

When we moved to Statesboro nearly 45 years ago, a number of people generously shared their knowledge of the history of Georgia Southern. Dan Bland would sit on his porch and talk about what he learned at the college when it was called the First District A&M School. Our neighbors Marie Wood, Tully Pennington, and Martha Cone Benson shared their memories about individual leaders and interesting personalities during their time as faculty and staff members. We wish to acknowledge their personal cultivation of our interest in the subject of this book.

We acknowledge the late Jack and Addie Averitt, who knew and loved this community and university. Dr. Averitt was an academic historian of the American South, but he also had a contagious interest in local history. We honor their memory, and we hope to communicate some of their enthusiasm for the subject at hand.

Unless noted otherwise, Georgia Southern University has provided the images that appear in this book. The Georgia Southern Museum and the Department of Special Collections of the Henderson Library have made available both photographs and information. The Office of Marketing and Communications shared with us a variety of photographs they have gathered over the years.

Mary Beth Spence and David Thompson helped us throughout this project. Jeremy Wilburn, the university's photographer, offered important images of the campus. Wendy Harrison of the Office of Special Collections at Henderson Library, our ally and friend, located and scanned rare images and helped us personally in numerous ways. We also wish to acknowledge the Bulloch County Historical Society and the Georgia Historical Society and the following individuals: Robert Benson, Parrish Blitch, Bill Broucek, Frances "Cookie" Deal, I.M. Destler, Gay Kimbrough Dull, Frank Fortune, Dan Good, Bruce Grube, Steve Gurr, Robert Haney, Deborah Harvey, Nicholas Henry, Jane Jackson Highsmith, Mary Thomas King, Betty Lane, Evelyn Darley Mabry, John Mallard, Ric Mandes, Michael McDougald, the family of Carole McGahee, Bede Mitchell, Charlton Moseley, Mildred Parrish, Susan Presley, Fielding Russell, R. Frank Saunders, Brent Tharp, Virginia Anne Franklin Waters, and Chester Webb. Finally, we thank many friends of Georgia Southern University who so generously have shared information, tips, and suggestions.

We have been committed to understanding the story of our university for many years. There is much more to its history than these vintage photographs and captions can provide. If the images and brief stories in this book stimulate your interest in this subject, we happily refer you to the university's centennial history: *The Southern Century: Georgia Southern University, 1906–2006.*

INTRODUCTION

Like a bright blue thread, a single idea runs throughout the fabric of Bulloch County history during its second century. The idea was central to a vision of an ideal Statesboro by James Alonzo "Lonnie" Brannen, Statesboro's first mayor. He unveiled his plan in an editorial in the *Statesboro News*. Brannen challenged citizens of Bulloch County to think boldly and plan to be the home of a real college in Statesboro. "Our people are progressive and it only requires an organized effort to reach out and grasp our opportunity to become the educational center of this section of Georgia. We can do it. Why not?"

A few months after the editorial appeared, Brannen's friend Joseph M. Terrell was elected to the first of two successive terms as governor. He was Georgia's "education governor," historians say. Terrell wanted to create a network of agricultural and mechanical schools in each of the state's 10 congressional districts. The governor knew the expense of building new campuses would force the state into bankruptcy, so he found a way to fulfill his dream without costing the state a penny.

Terrell correctly assumed that some communities would pay the initial sum to build a campus. The cost would include sufficient land, two dormitories, and a large academic building. The state would pay a large share of the continuing annual expense. What the governor envisioned came to pass, and the legislature finally approved his ambitious program in the spring of 1906. Terrell attended all bidding sessions scheduled for each of Georgia's districts. Statesboro happened to be located at the center of the First Congressional District.

Early on Saturday morning, December 1, 1906, a delegation of 50 leading citizens from Bulloch County boarded the Savannah & Statesboro Railway passenger train. They were bound for Georgia's colonial capital of Savannah. There, they would bid to host the First District A&M School. Brannen, who introduced the idea in 1901, was on board. Delegates had read, no doubt, the front-page editorial in Friday evening's *Statesboro News*. Editor J.R. Miller, also on board, had warned fellow delegates, "Bulloch County must have that college . . . regardless of the cost."

According to conventional wisdom, Chatham County would offer an extravagant bid that no one could top, but officials in Savannah inexplicably failed to sign up for the bidding contest scheduled conveniently at the DeSoto Hotel at the corner of Bull and East Liberty Streets. So, the door was open for inland counties, assuming they were willing to pay the cost of building the campus. Bulloch County's delegation included most business and shop owners in Statesboro, as well as doctors, ministers, lawyers, and virtually every elected public official. On that Saturday, more than a few who rode the train to Savannah would pledge land or money or both.

Reporters noted that debates were heated and, at times, hilarious. The headline above the article in the Sunday edition of the *Savannah Morning News* tells the story: "Bulloch Lands District College: Statesboro Site Chosen." The newspaper reported in detail Saturday's drama that ended with the approval of Statesboro's bid. Local delegates offered 300 acres of land atop the town's highest hill, utilities, and $60,000 in cash, totaling $125,500. Statesboro's

final bid was $23,000 higher than the nearest competitor. In the economy of the 21st century, the winning bid would be valued at several million dollars.

Without such a dedicated group of bidders, what is now Georgia Southern University might be located in the community of Hagan, near Claxton in Evans County; at Stillmore in Emanuel County; or in Burke County's seat of government, Waynesboro. Or it might have floundered.

Several district schools failed; only five survived as colleges, but the First District School in Statesboro has a unique history. In 1924, it became the only state A&M school to gain classification as a normal school. In 1929, it became the state's second four-year coeducational public college. In 1990, it was the first former A&M to become a university.

The transition to South Georgia Teachers College in 1929 was critical and historic. Had not the president and board of trustees convinced the legislature to elevate the status from a junior to a senior college in August 1929, the state could not have authorized such a move two months later or even during the two following decades of the Great Depression and World War II. In 1929, the college in Statesboro became second only to the university in Athens to serve Georgians as a state-supported coeducational college that offered bachelor's degrees—a distinction it held for more than two decades.

In 1932, when the Depression severely reduced tax revenues, the State of Georgia consolidated its colleges into a single administrative unit, the University System of Georgia, governed by a board of regents. This centralized authority, whose members are appointed by the governor, approved three institutional name changes: Georgia Teachers College (1939), Georgia Southern College (1959), and Georgia Southern University (1990).

In the second decade of the 21st century, the university serves more than 20,000 students who pursue bachelor's, master's, and doctoral degrees in eight colleges. In recent years, the university has achieved national recognition for its excellence and innovation. *U.S. News & World Report* recently ranked it among America's 10 most popular institutions of higher education.

A key player in the regional economy, the university is Bulloch County's largest employer and is among the top-five employers in the entire coastal region of the state. Economic surveys reveal that some 10,000 people have jobs that depend on the presence of the university. In the second decade of the 21st century, the university's annual economic impact exceeds $840 million.

The leader and president for the first decade in the current century, Bruce Grube set Georgia Southern on a course toward national distinction. The current president, Brooks Keel, is defining a new era of service and excellence. Leaders in this century appear to be true to the aspirations of those who preceded them.

This volume is not a typical history, of course, but a perspective on the past—a story told through images. Instead of focusing on a timeline from 1906 to 2000, the authors have prepared chapters on these topics: community, leadership, academics, student life, athletics, and campus. Each chapter includes text and photographs that represent significant events chronologically. We hope this approach will allow readers to better understand the people, especially students, who played major roles in this remarkable academic institution.

Like any individual, an institution's formative years are critical. We have deliberately tried to uncover the earlier decades in the 20th century and to locate images that reflect the character of this place. The saying "a picture is worth a thousand words" is only partially true. If words provide the actual context for the picture, both the picture and the words unlock the past.

The history of this institution has nostalgic moments, of course, but it also resonates with stories of courage and compassion. When we learn about people who once walked the path we take today on Sweetheart Circle, how can we write off the experience as mere nostalgia? One hundred years ago, learners and leaders passed beneath the same trees that tower over the northern entrance to the university: the Herty pines. Georgia Southern University today

is more than a place where people learn; this campus prods us to ponder how to connect with a past that physically resembles the present.

Chapters one and two interpret the significant role of the community in the origin and ongoing success of the institution. In times of crisis, the "college on the hill" has been well served by talented leaders who performed honorably and, at times, heroically. Some have been agents of change, and others have mediated conflict.

Times change, but not all colleges do. The school in Statesboro thoughtfully shifted its curriculum to meet the needs of a growing and changing state. Unlike some A&M schools, this one did not close its doors; rather, during its first decade, it opened the entrance even wider for students who wanted to become certified teachers. In 1924, Principal Ernest Hollis became the first president of a college called Georgia Normal School. The success of the old A&M school exceeded the founders' fondest dreams.

Chapter two reviews images of earlier leaders who seem to have known the right moment to accomplish the institution's mission. To date, 12 individuals have served as president. Those who did not achieve their goals seemed to realize their successors would take up the challenge. A case in point is the leader who, in 1990, finally achieved what presidents for 50 years had not—university status.

Chapter three focuses on the heart of the university: academics. Georgia Southern has a history of introducing students to timeless truths that enable them to make timely decisions for their generation. In 1906, the purpose of the A&M school was to prepare men and women to succeed in a farm-based economy. Today's talented professors enable graduates to compete for important jobs, both locally and internationally, in fields of education, business, industry, technology, health services, information technology, and other areas of human enterprise.

Chapter four reveals the truth behind the truism that presidents and faculty may come and go, but students are forever. They are the movers and shapers of the university's future. Present meets past when today's students read the *George-Anne*, sing the alma mater, and cheer for the Eagles. Sports, lectures, music, and campus publications all play a role in defining what it means to be a Georgia Southern student.

Chapter five shows how athletic teams provide students and alumni with a sense of loyalty and unity and how coaches can teach as well as build up the morale of the larger community. The first published news about sports on campus was in 1909, when some students began to practice football. During its first decade, teams nicknamed "The 'Culture" represented both the campus and the community on the football gridiron, baseball diamond, and basketball court. By the end of the century, the university was fielding more than a dozen female and male athletic teams competing in NCAA Division I events.

Chapter six concludes this pictorial history with an overview of a campus that many students and faculty believe to be one of America's most beautiful. Readers can gain insight into how this campus grew from three buildings on 300 acres to more than 180 buildings on some 950 acres. At the center of the campus since the 1990s is a beautiful memorial to all who lived out their careers here. It is called Builders of the University Terrace, a fitting tribute for the descendants-in-spirit of the fabulous 50 that took the train to Savannah on December 1, 1906.

One

THE TOWN THAT MADE THE GOWN

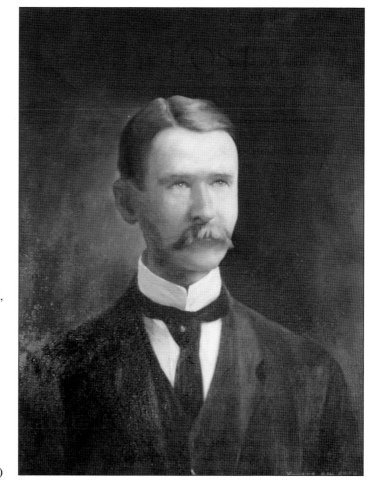

James Alonzo "Lonnie" Brannen (1857–1923) moved to Statesboro in 1879 when only 24 people lived there. Although the State of Georgia recognized Statesboro as the seat of government for Bulloch County in 1803, it did not grow until the late 1880s, when Brannen was elected the town's first mayor. In 1901, his newspaper editorial challenged citizens to invest in making Statesboro the home of a "real college." (Courtesy of Cecil Howard and Statesboro City Hall.)

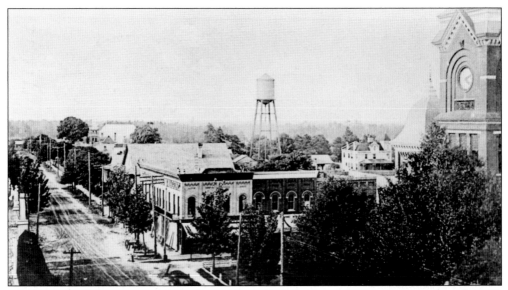

By the turn of the century, Statesboro claimed the role as a major inland city of south Georgia. Donations by citizens paid for an attractive and unique courthouse in 1896. By 1905, Statesboro had become a leading market for cotton in the United States. The town treasured its enterprising merchants and industrious farmers. Yet, it had not fulfilled Mayor Brannen's dream of having its very own college.

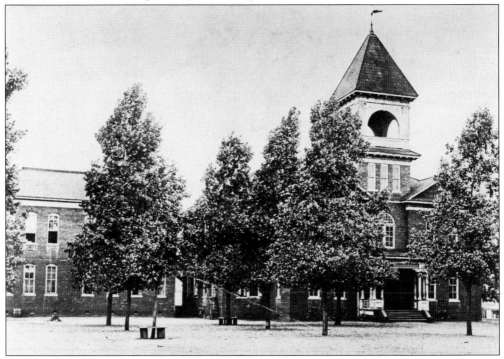

In 1901, Statesboro had a college on College Street, but it did not meet the mayor's definition of a real college. It was, in fact, a business school that emphasized secretarial training. The formal name of the educational institution was Statesboro Institute and Business College. The majority of students were enrolled in the institute in grades 1 through 11.

12

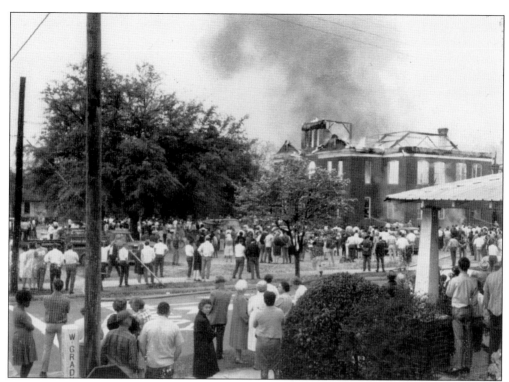

The old business college eventually became a junior high school. Citizens enjoyed viewing the quaint schoolhouse before it burned in the late 1960s. The high school previously had moved from Grady Street to a new location on Lester Road. The school site became the home of the Statesboro Fire Department and EMS for Statesboro. The old college building was vacant when it burned.

Georgia's "education governor," Joseph M. Terrell, initiated and signed legislation authorizing a state-supported agricultural and mechanical school in each of the state's 10 congressional districts. The bill passed the legislature in 1906, because it required local communities to submit agreements, plans, and cash to supply sufficient land, three main buildings, and related start-up costs. At last, Statesboro had an opportunity to host its own college.

THE STATESBORO NEWS.

$1.00 A YEAR. STATESBORO, GA. FRIDAY, NOVEMBER 30, 1906 VOL. 6 NO 39

Bulloch County Must Have That College.

Tomorrow, at 10 o'clock, the trustees of the First district agricultural college will meet in Savannah for the purpose of organization and the consideration of the bids for the location of the school for this district.

That there will be some spirited bidding for this school is confidently expected. Up to date the following places have entered the fight for the college: Statesboro, Claxton, Hagan and Sillmore. Both Swainsboro and Waynesboro figured on it at one time, but according to the latest information they have each withdrawn from the fight. It is the concensus of opinion throughout the state that it will be located at Statesboro, but sometimes "the best laid plans of mice and men o'miscarry."

Bulloch county stands at the top of the great agricultural and industrial counties of the state. She is the wearer of the blue ribbon for the best agricultural county in Georgia, having won it over the stiffest sort of competition at the state fair recently held in Atlanta.

The lists that have been circulated throughout the county asking that the county commissioners put into effect the recommendation of the last grand jury to appropriate $25,000 or more if necessary to this fund, have been universally signed where they have been circulated. In some localities the list has not been presented for lack of time, but where they have shown that they understand its purpose and importance. In the Brooklet district we learn only one man refused to sign; only one in the Briar Patch; only one in the Blitch; only three in the Laston; three in the Club House and practically none in the other districts.

The feeling is unanimous for the committee to go down to Savannah tomorrow and simply get the college, that there shall be no limit to the amount that we shall pay for it in reason. They un-

Bulloch County Boy Making Fine Record.

Perhaps it will be interesting to the many acquaintances and friends of Rufus Cecil Franklin to know something of his standing and success in class work, generally, since entering the University of Maryland, in Baltimore.

He is a son of Mr. Jason Franklin, of Adabelle, this county, who is a most highly respected and influential farmer in that section as well as a great promoter of higher education.

His son, referred to above, entered the University of Maryland school of medicine in October, 1903, and since that time has been earnest and successful in learning the science and art of medicine, making a popular standing in his class each successive year. In his junior year he held the office of vice-president of his class, and at the end of that year he was among the number appointed as clinical assistants at the university hospital. Here he spent the entire summer and will continue to be connected with hospital work until his graduation, which will be May 31st, 1907. Since beginning his fourth year of medicine he has been elected president of his class, which is an unusual

South Georgia Conference Invited Here Next Year.

The South Georgia Methodist Episcopal conference, which is in session at Valdosta this week, will be invited to meet here next year. The invitation will be extended through the venerable pastor of the church here, Rev. G. G. N. MacDonell. It is hoped that the invitation will be accepted.

The church here is in a very prosperous condition, and, under the charge of the present pastor, has had one of the best years in the history of the church. That Statesboro can take care of a meeting so large there can be no doubt. In the past she has had a meeting almost as large and the way that the visitors and delegates were cared for won their hearty applause. That was two or three years ago and the city has grown greatly since that time; Statesboro has never had the honor, we believe, of having this distinguished body of churchmen meet here, and for this reason the people are more than anxious that the conference meet here for its next session.

Made Happy for Life.

Great happiness came into the home of S. C. Blair, school superintendent,

Thanksgiving Observed Here.

ThanksgivingDay was generally observed in Statesboro yesterday. The stores, banks and business houses were all closed, and the

A Year of Blood.

The year 1905 will long be remembered in the home of F. N. Tackel, of Alliance, Ky., as a year of blood which flowed so copiously from Mr. Tackel's lungs that death seems very near. He writes "Severe bleeding from the lungs and a frightful cough

Mayor Brannen's challenge of 1901 became an opportunity on December 1, 1906, when 50 citizen-delegates traveled to Savannah, where many emptied their bank accounts in order to submit the highest bid for the right to host the school. Delegates agreed that getting the college for Statesboro was worth the cost of 300 acres of land and cash that, in today's economy, would amount to several million dollars.

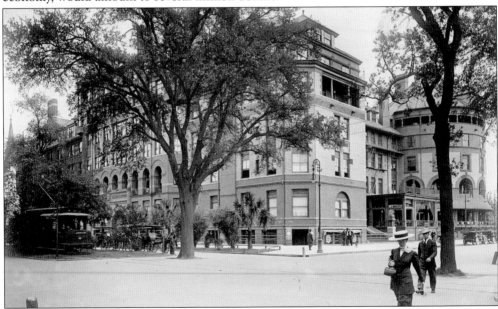

In September 1906, the DeSoto Hotel announced it would host the First Congressional District A&M School bidding competition on December 1. Statesboro's delegation of 50 included the leadership of the county, including its lawyers, ministers, merchants, elected officials, and farmers. Delegates from other communities, likewise, flooded the DeSoto. The huge turnout forced the governor to seek a larger space nearby. (Courtesy of the Georgia Historical Society.)

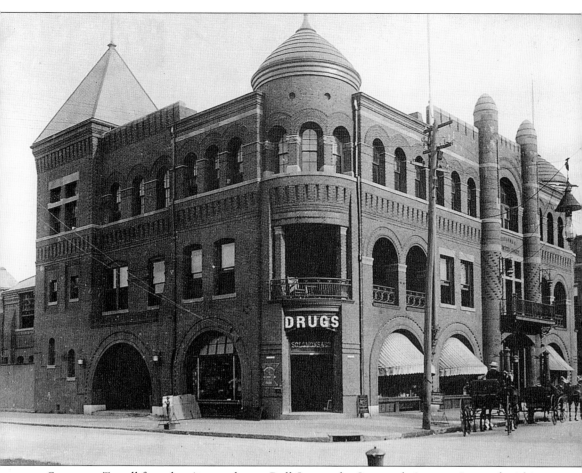

Governor Terrell found a site nearby on Bull Street, the Savannah Armory. Located within walking distance of the hotel is the official birthplace of today's Georgia Southern University. Witnesses said the proceedings at the armory were both tense and hilarious, as contenders parried, using verbal humor. Although Statesboro's final bid was more than $20,000 higher than the nearest competitor, the temporary first district trustees were knotted for more than an hour—six for Statesboro and six against—as the sun sank that Saturday afternoon. Governor Terrell broke the tie in favor of Statesboro. (Courtesy of the Georgia Historical Society.)

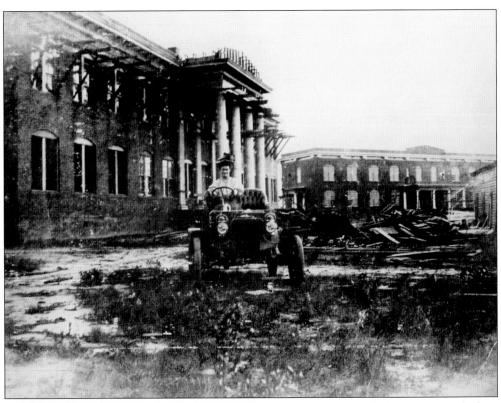

Citizens of Statesboro were proud of their college located atop Statesboro's highest hill. The first car owner in Statesboro was Percy Averitt. On a Sunday afternoon in 1907, Averitt took a picture of Myrtle Smith (later Mrs. C.P. Olliff Sr.), who appears to be driving the horseless carriage through the construction site of the familiar landmark buildings the contractor finished during the summer.

J. Walter Hendricks, the first principal of the First District A&M School, was a Bulloch County native. He was valedictorian of his graduating class at the University of Georgia. Although he was the logical leader for the new school, he left after his first year and moved to Douglas, Georgia. Eventually, he became a celebrated preacher and esteemed leader of the Primitive Baptist denomination. (Courtesy of Edwin M. Hendricks.)

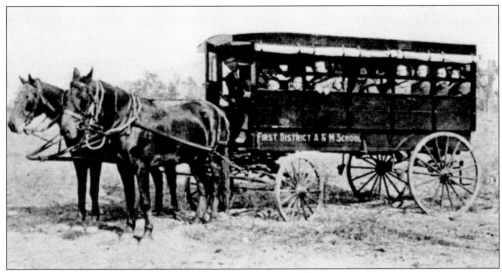

Students appreciated A&M's mule-powered omnibus that was used primarily to transport students to and from downtown Statesboro and its churches, shops, and train stations. In December 1914, the campus experienced its first major disaster when the barn that housed the omnibus caught fire. The school's first bus was burned beyond repair. Fortunately, the students rescued the mules from the flames.

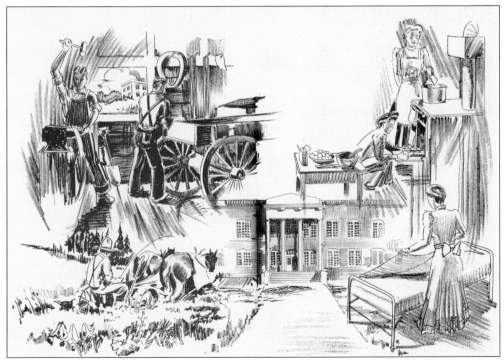

Looking back on the history of the college in 1941, the *Reflector* yearbook staff included some sketches depicting critical changes of the mission. Originally, the A&M school prepared students to be successful in a society that depended on farming and domestic skills. The *Reflector* staff concluded that the college in Statesboro prepared students for new careers as the 20th century unfolded.

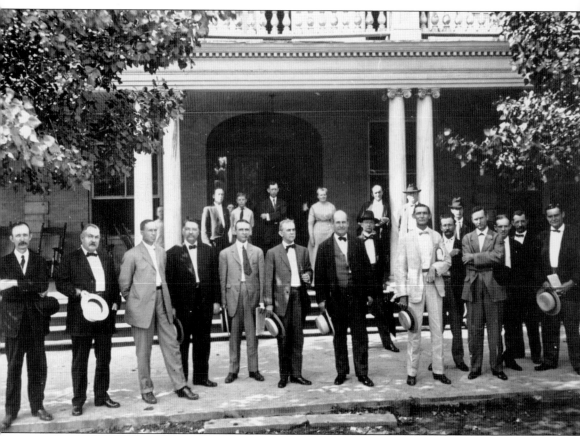

On June 13, 1911, A&M principal Dickens welcomed the three-time presidential candidate for the US presidency, William Jennings Bryan, who found a large and responsive audience in Statesboro. Others present for this photograph in front of the Jaeckel Hotel include, from left to right, (first row) Dave Turner, Henry Olliff, Bird DeLoach, Wiley Williams, two unidentified men, W.J. Bryan, James Alonzo Brannen (with umbrella and hat), Principal E.C.J. Dickens (with package), Gordon Blitch, Dr. Raymond J. Kennedy, Howell Cone, Sam Groover, and J.J.E. Anderson; (second row) unidentified man, Shelton Paschal (boy), Brooks Simmons, hoteliers Mrs. and Mr. Paschal, E.C. Oliver, and Ewell Brannen (on bottom step).

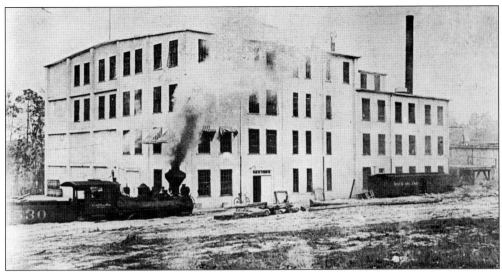

In 1916, trustees rejected a developer's proposal to place a meatpacking plant on the northeastern corner of the campus. They said the plans were inconsistent with the school's goals. Disappointed, the proposal's supporters later built the plant on what became Packinghouse Road. The business declared bankruptcy and folded in the late 1920s.

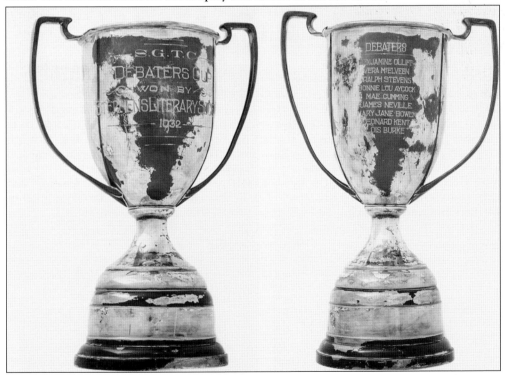

School professor Josephine Schiffer organized the first literary society, the Persephonians, in 1909. Later, it dissolved to form two debating clubs, the (Alexander) Stephens Society and the Oglethorpe Society. In 1917, the rivals debated whether American women should be given the right to vote. The judges from Statesboro, Walter McDougald, Charles Pigue, and Hinton Booth, sided with the affirmative.

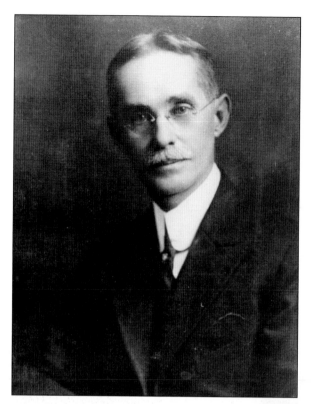

In 1900, John A. McDougald invited chemist Charles Holmes Herty (pictured) to conduct experiments with pine trees at the site of what became the college entrance on US 301. He documented a method of obtaining resin and discovered how to transform pine pulp into newsprint. In 1935, the college honored him by dedicating the Herty pines.

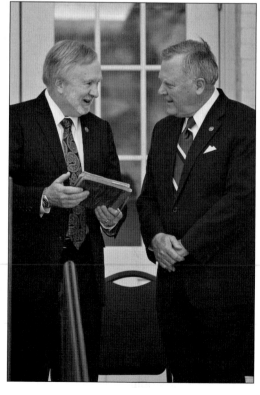

On April 24, 2012, Georgia governor Nathan Deal transferred management of the Herty Advanced Materials Development Center to the university. The center conducts research on natural materials and products for international industries. University president Brooks Keel shows Governor Deal (right) the detailed notebooks Herty used in 1901 on the site of the campus.

Two

THE ART AND CRAFT OF 20TH-CENTURY LEADERS

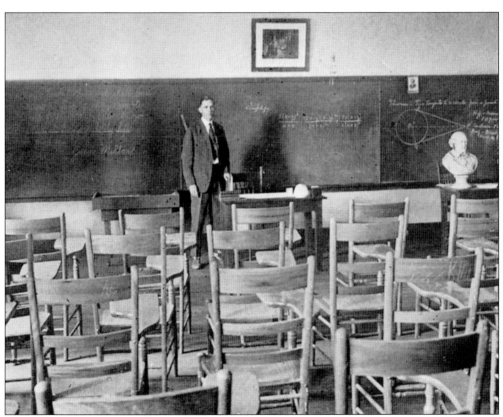

After Principal E.C.J. Dickens resigned in 1914, the trustees passed the torch to a man who had been a part of the faculty since the beginning. For six years, F.M. Rowan worked to see if the A&M concept would continue to attract students. In 1915, he began to expand the offerings to attract people who wanted to become teachers. He ended his effort in 1920 and concluded his career as a faculty member at Georgia Tech. Rowan stands in his second-floor mathematics classroom in the Administration Building.

Trustees made a key decision when they appointed the school's fourth principal in 1920. Ernest Victor Hollis had graduated from Mississippi State University and had earned two master's degrees before beginning his doctoral program at Columbia University. Hollis thought the opportunity to lead a college was too good to pass up. In 1920, at age 24, the energetic leader moved to Statesboro with his wife and infant son.

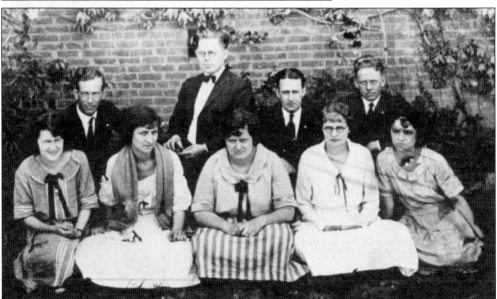

Since the school had been training teachers since 1915, Hollis reorganized the faculty, emphasizing agriculture less and the liberal arts more. The new faculty members of 1923 pictured here are, from left to right, (first row) Inez Rudy, Lila Blitch, Janice Jones, Elizabeth Bruce, and Clara Leek DeLoach; (second row) Davis Nye Barron, President Hollis, Albert Quattlebaum, and Wiley M. Pope. With a strong faculty and a progressive board of trustees, young Hollis convinced the legislature to change the school from of A&M to Georgia Normal School—a college devoted to preparing teachers.

Hollis invited the superintendent of schools of Eastman, Georgia, Guy Wells, to become the new dean in April 1926. Two months later, Hollis announced his decision to complete his doctorate at Columbia University. Trustees decided that Guy Wells was the man for the top job. He administered the summer school in 1926, three months after moving to Statesboro.

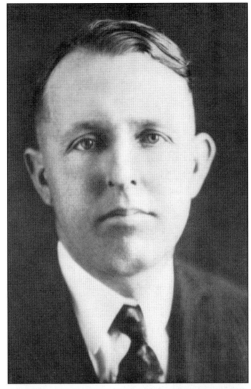

Guy and Ruby Wells had two children, Guy Jr. and Anne. Some students claimed Anne (pictured here with mother Ruby) was named for the campus newspaper, the *George-Anne*. They elected her as campus mascot. The larger of the two lakes at the center of campus, Lake Ruby, is named for Guy's wife.

In May 1929, President Wells invited Georgia governor Lamartine Hardman to visit the campus. Wells had spoken with him about the possibility of upgrading Georgia Normal College from two years to four and changing the name to South Georgia Teachers College. Governor Hardman stands in the center of the first row with faculty, students, and trustees (and is also pictured below on page 25). Albert Deal is on the far right, observing the scene.

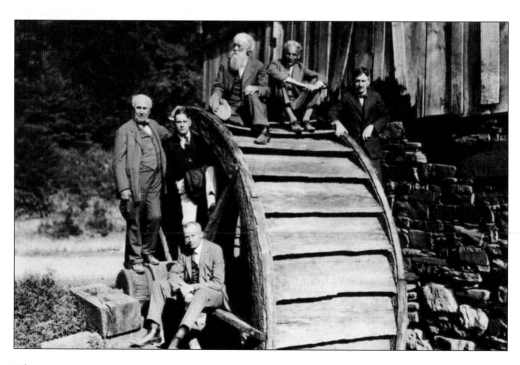

When the legislature met for the summer session, Governor Hardman permitted Bill No. 379 to go forward. State senator Howell Cone and state representative Harvey Brannen helped persuade lawmakers to pass the bill. The governor transformed the college from a two-year to a four-year institution on August 24, 1929. Just two months later, the Great Depression began.

Opposite page: R.J.H. "John" DeLoach joined the social science faculty of the college in 1928. He was a native of Bulloch County and worked for Armour and Company in Chicago. His impressionistic biography of American naturalist John Burroughs and his wide-ranging contacts resulted in an invitation to join an exclusive camping group of six, known as the "Vagabonds." The group included legendary inventors of the 20th century. DeLoach is seated at the base of the waterwheel. Thomas Edison (left) and Harvey Firestone Jr. stand nearby, John Burroughs (left) and Henry Ford are atop the wheel, while Harvey Firestone Sr. stands on the right side.

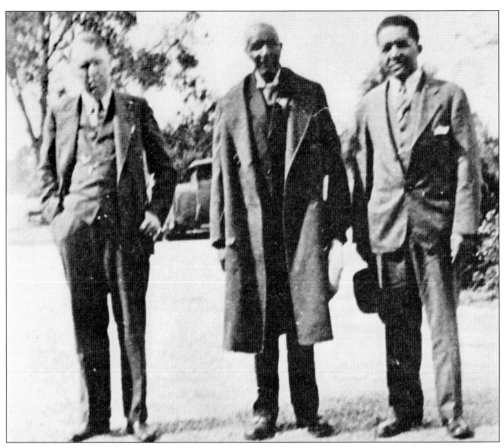

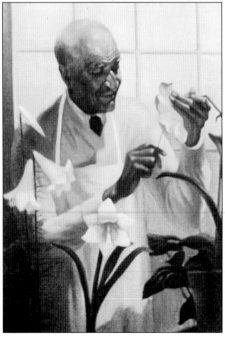

Pictured above on October 31, 1933, President Wells (left) welcomes Dr. George Washington Carver of Tuskegee Institute (center, and seen at left) and their mutual friend, Benjamin Hubert, president of Savannah State College. Carver's humility and scholarship deeply impressed an initially apprehensive audience of 1,000. Wells and Hubert began planning a tour for Dr. Carver throughout Georgia's colleges and universities for the next academic year. They hoped to encourage interracial understanding in Georgia. Then, Wells learned that the board of regents, in its second year of operation, planned to transfer him to the presidency of Georgia State College for Women (GSCW) in Milledgeville. He later told the GSCW faculty that he was forced into his new assignment. Some observers believed the transfer was an implicit rejection of his early effort to improve race relations. (At left, courtesy of Tuskegee University.)

A 1930s photograph of Mr. and Mrs. J. Randolph Anderson reveals them in midlife. Mrs. Anderson, formerly Paige Wilder, was a close friend of her husband's cousin Juliette Gordon Low, and she volunteered to be the first Girl Scout leader. Randolph, a prominent Savannah attorney, was board chairman for the first 17 years of the school. When he retired, the school-turned-teachers college was well on its way to a bright future.

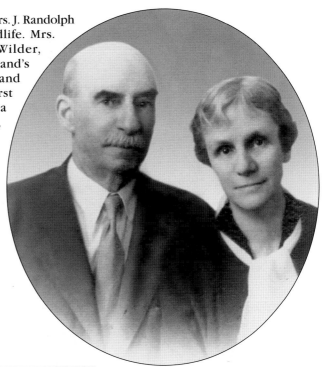

Marvin Pittman, the third president and a native of Mississippi, received his doctorate at Columbia University. He came to the campus in 1929 and impressed an audience of 1,200. Pittman became president in the fall of 1934. He was also the director of the rural education program at what later was known as Eastern Michigan University. At the time, he was the Democratic Party's nominee for the US Senate from Michigan.

After the board of regents removed the word "South" from the institution's name in 1939, Georgia Teachers College gained an identity as a college whose graduates did not live by desire but by devotion to knowledge—the true liberator. In a yearbook dedicated to the Rosenwald Fund, students supported Pittman's progressive efforts. A student artist drew this visionary image of the role of this college.

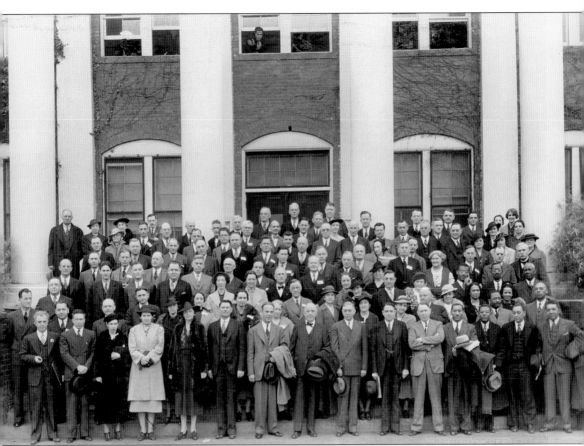

Some politicians, regents, and a few faculty members thought Pittman was controversial because he invited 12 African American educators (far right, first through fourth rows) to a conference of predominantly white teachers and administrators. He wanted to share progressive ideas with teachers who educated all children of America. The chancellor of the University System of Georgia, Steadman V. Sanford (wearing the bow tie) stands near the center of the first row with President Pittman (sixth from the left) and representatives of the Rosenwald Fund.

Advised by Georgia governor Eugene Talmadge, the board of regents fired President Pittman at its May 1941 meeting. The college and community lost a leader. The governor also insisted that five popular faculty members should be fired, including influential historian Dr. Chester Destler. Some local Talmadge loyalists insinuated the five likely were German sympathizers or communists. Pittman is pictured on the left, with pencil beneath his chin, at the capitol hearing in July 1941.

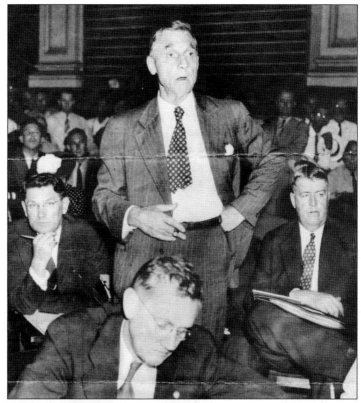

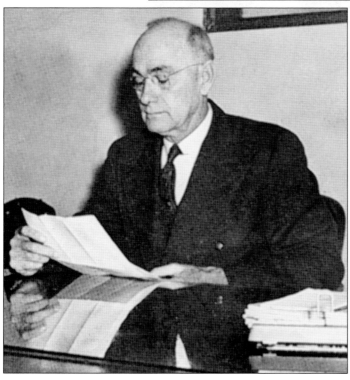

Albert Martin Gates, an able president of a small Baptist college in Mount Vernon, Georgia, reluctantly became the leader of the teachers college. As Governor Talmadge instructed, Gates released five popular professors at the college without ever meeting them. Four months after Gates was inaugurated, World War II began and enrollment plummeted. Chancellor Sanford suggested that the college should relocate to Savannah and a trade school could occupy the Statesboro campus, but the citizens of Statesboro adamantly opposed the idea.

BACK TO THE
TOP WITH
PITTMAN!

The George-Anne

T. C.
MARCHES
ON!

Published By The Students of Georgia Teachers College

VOL. 16 COLLEGEBORO, GA., MONDAY, FEBRUARY 8, 1943 NO. 7

Pittman Takes Over Today

SENATE APPROVES FIFTEEN REGENTS

Marion Smith, Atlanta, To Serve As Chairman

Following the reorganization of the Board of Regents under a bill passed by the 1943 General Assembly, Governor Ellis Arnall promptly appointed a new Board of Regents who were confirmed by the State Senate.

The new members and the terms for which they were appointed follow:

J. L. Renfroe, Bulloch county, representing the First congressional district, to serve until January 1, 1948.

Ed Jerger, Thomas county, representing the Second district, until January 1, 1944.

George Woodruff, Muscogee county, representing the Third district, serving until January 1, 1941.

C. J. Smith, Coweta county, representing the Fourth district, until January 1, 1949.

Rutherford L. Ellis, Fulton county, representing the Fifth district, until January 1, 1947.

Miller S. Bell, Baldwin county, representing the Sixth district, until January 1, 1950.

Roy Emmett, Polk county, representing the Seventh district, until January 1, 1945.

Prince Gilbert, Glynn county, representing the Eighth district, until

DR. MARVIN S. PITTMAN

TEACHERS COLLEGE RESTORED TO FULL ACCREDITED STATUS

Membership In Southern Association Reinstated As Of September 1, 1942, The Date Schools Were Suspended

Noted Educator Returns to Former Post as Head of Teachers College

Dr. Marvin S. Pittman, who for seven years served as president of Georgia Teachers College and was fired in July, 1941, by a "stacked" Board of Regents on false political charges, returns today as executive head of the college after an absence of eighteen months. The reinstatement of Dr. Pittman was one of the first actions taken by the new constitutional Board of Regents at their first meeting last month.

Pittman, since leaving Teachers College, has been serving as Director of Instruction at Louisiana State College at Natchitoches, La., where he did his first college teaching.

'Charm,' Masquers' Winter Production

Dramatic Presentation Is Comedy; Complete Cast Has Been Selected

"That elusive, intangible, indefinable something that you cannot put your fingers on." The Masquers guarantee that you will know the answer to this mysterious riddle if you see their next stage production, "Charm," a comedy in three acts. The play is scheduled for presentation on February 25th.

The action of the play is laid in a small American town in pre-war days. The plot of the production revolves around the troubles of an average family who has a young daughter loved by two men. Their exploits

Bastile Trial Day

Along with Dr. Cocking, of the University of Georgia, Pittman was tried at a "mock trial" on July 12, 1941, by a Board of Regents who had already received a typed verdict from former Governor Talmadge before the trial began. After Pittman left the college on September 1, 1941, and was succeeded by Dr. A. M. Gates, who had been president of the college at Mount vernon. Gates relinquished his position last week by order of Regents, and at the same time the board named Dr. Pittman to succeed Gates.

Rehires Michael

Miss Mae Michael, who served under three presidents as secretary, was rehired last week by Dr. Pittman as

After reviewing Governor Talmadge's interference in higher education, the Southern Association of Colleges and Schools revoked its accreditation of the University System of Georgia's white colleges. The people of Georgia determined not to reelect Talmadge. After Ellis Arnall was sworn in as governor in 1943, he invited Dr. Pittman to resume his presidency of the college. Pittman joked about his "Talmadge sabbatical." The *George-Anne* welcomed Pittman's return.

In 1946, after Eugene Talmadge reclaimed the governorship, a wiser Pittman retired from the University System of Georgia. During his retirement, he helped reorganize schools in war-torn Europe as part of the Marshall Plan. He also became the college's first alumni director. Pittman recommended that his replacement should be Judson "Jake" Ward, a history professor at West Point who earlier taught on the Statesboro campus and recently had received his doctorate in history. Pictured here, Ward was inaugurated in October 1947.

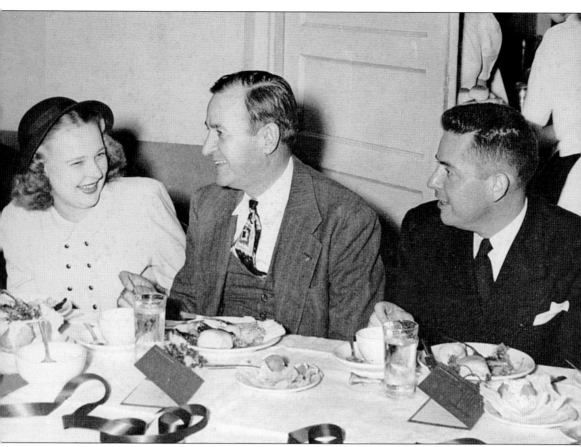

President Ward was forced out of his job after only seven months because some regents believed his policies proved he was a "Pittman man." Although his term was brief, the amiable Ward was popular in Statesboro. He ended his career at Emory University, where he was dean for 36 years. At the inaugural luncheon in Anderson Dining Hall are, from left to right, Mrs. Judson (Susan) Ward, Georgia governor Melvin Thompson, and President Ward. (Courtesy of Judson Ward.)

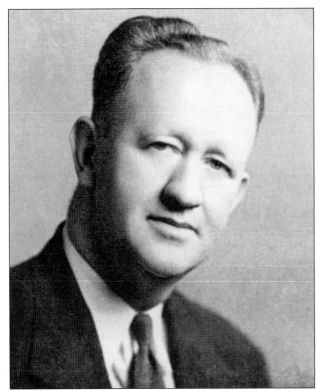

Dean Zach Suddath Henderson loyally served 20 years as dean for four presidents. The board of regents appointed him president in 1947. His tenure of 21 years is the longest in institutional history. Noncontroversial by nature, the likable Henderson oversaw an unprecedented enrollment increase, partially due to the many former soldiers who were on campus courtesy of the "G.I. Bill" for World War II veterans. Campus facilities more than doubled.

Dean Zach Henderson of Gillsville married Marjorie Clark of Eastman in 1927, just before they moved to Statesboro. Their children were Gene, Mary, and Ann, all of whom grew up on the college campus where their father was dean and president until his retirement in 1968.

President Henderson made famous an institution that traces to the early days of the college: ice-cold watermelon cuttings during summer months. In his retirement years, he visited the campus often and enjoyed the cool treat while talking about campus history with faculty and students, including first-grader Edwin Presley and his father in 1979.

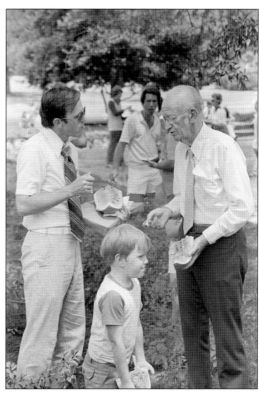

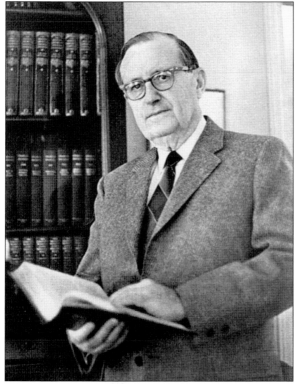

Dr. John Eidson, formerly a professor of English literature and dean at the University of Georgia, was elected the sixth president and began his work at the start of the 1968–1969 academic year. Hoping to elevate the college to university status, he reorganized the college into schools and departments and produced an organizational chart. He sought to enhance academics and secured endowed Callaway professorships in both biology and business.

Another subtle gesture toward university status was Eidson's introduction of an academic vice president, a new position. Pope A. Duncan defined the new position as a way to enhance the continuing professionalization of the faculty. His benchmark for new faculty was doctoral-level education. He also sought to attract nontraditional students to the college through a new Department of Continuing Education.

In the early 1970s, the Vietnam War provoked campus demonstrations, and student activists proposed a list of grievances to the administration. A protest leader, Ric Muccia presented President Eidson with a list of 24 grievances. To the student body's surprise, the president was responsive and asked students to monitor changes and continue to meet with him.

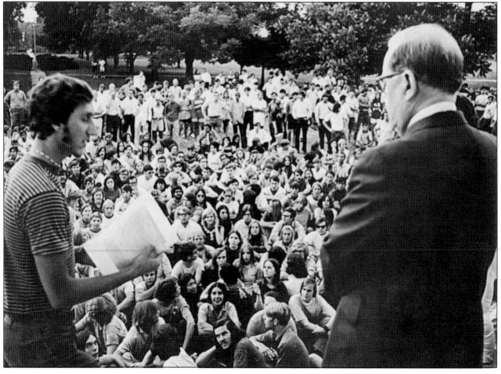

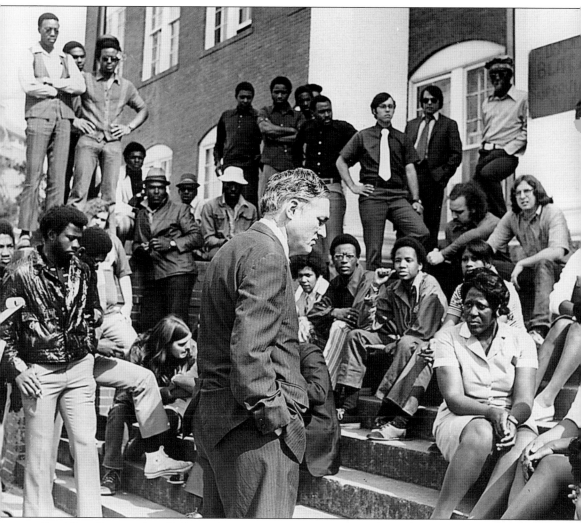

President Duncan handled a major controversy in 1972. Cooks and service workers at the cafeteria walked off the job because of low wages of $1.75 per hour. In addition to demanding a living wage, the protestors made an additional request: the college should hire at least one African American professor. Nicholas Quick, the vice president, negotiated a pay hike of 15 percent. The college later hired Dr. Charles Wesley Bonds as an instructor of reading, the first African American on the faculty payroll.

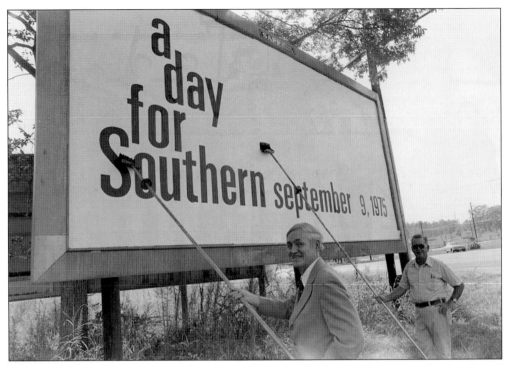

Vice President Duncan helps Mr. Sapp install a sign advertising the "A Day for Southern" campaign for 1975. Originally called "Pull for Southern," the campaign, which was suggested by local architect Edwin Eckles, brought in $15,000 in 1972. By 1975, "A Day for Southern" volunteers collected $60,000. In the early 21st century, the day's fundraising proceeds typically are in the range of $1.5 million.

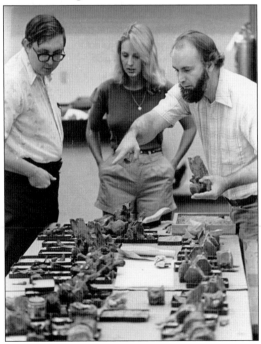

Geologist Dr. Gale Bishop (right) collected a virtually complete specimen of a mosasaur in South Dakota and brought it to the campus in the late 1970s. It is the well-preserved fossilized remains of a 28-foot-long marine varanid lizard that lived in the sea during the last 20 million years of the Cretaceous Period (about 45–65 million years ago). Because of the importance of this collection, Georgia Southern opened a museum in the Rosenwald Building in 1982. Dr. Bishop, who was the first museum director (1980–1982), shows a section of vertebrae to John Heard (left) and another visitor to his laboratory in the Herty Building.

In 1978, the search for a replacement for President Duncan was the first nationwide search the board of regents had authorized in the history of the institution. Dale Wesley Lick previously was dean of sciences and health professions at Old Dominion University. The 40-year-old president told the Georgia Southern faculty the following: "My core belief is a commitment to the worth and dignity of people." He created a new staff position, the affirmative action officer. He appointed sociology professor Dr. Harris Mobley to recruit minority students and faculty.

President Lick found a team of respected professionals in nursing and health care to begin his first major initiative to meet the educational needs of south Georgians. The team included, from left to right, Martha Coleman, Joyce Murray, and Em Bevis. The trio developed a curriculum in nursing that focused on rural health, and they led the program to full accreditation. In the 21st century, professional reviewers consistently give the nursing program excellent marks, and the *U.S. News & World Report* ranking of the nurse practitioner degree program typically is in the magazine's highest category in the nation.

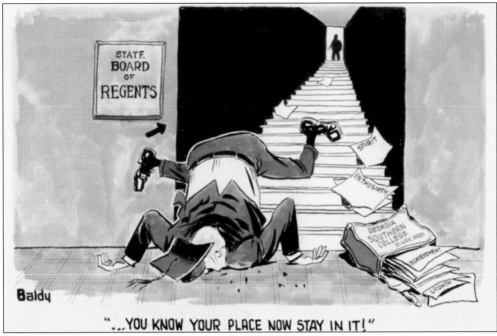

"...YOU KNOW YOUR PLACE NOW STAY IN IT!"

In June 1981, the board of regents concluded that President Lick had acted improperly when he called for equitable funding and university status. The chairman of the regents asked for Lick's removal, a motion that narrowly failed. Then, the board unanimously censured him. Enrollment grew rapidly after 1982, yet the regents did not approve any new construction until 1986, after Lick resigned and became president of the University of Maine. Lick's treatment became the subject of two influential cartoons by the venerable Clifford "Baldy" Baldowski of the *Atlanta Constitution*. Soon, Dale Lick was well known in the state, and many citizens identified with him and his college in Statesboro. Lick became a folk hero in the eyes of many in all corners of the state.

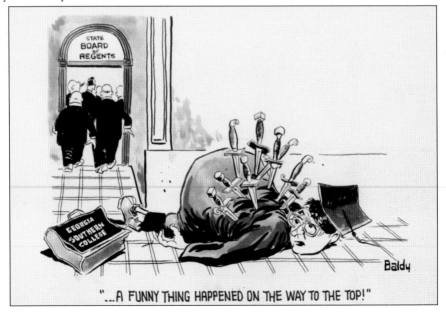

"...A FUNNY THING HAPPENED ON THE WAY TO THE TOP!"

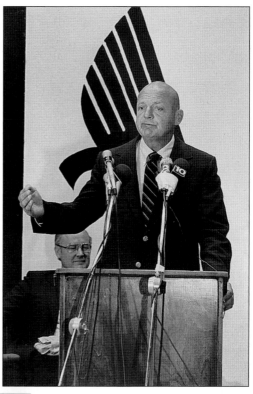

Although most faculty members were skeptical about reviving a sport that went dormant during World War II, the president sided with enthusiastic alumni. Lick had the audacity to go to Athens and invite the defensive coordinator for the University of Georgia's Bulldogs to start a program from scratch, and Erskine "Erk" Russell (at left) said, "Yes." The "Bald Eagle" began the program as a club sport in 1981, and three years later his Eagles were national champions of Division 1-AA football. Before he retired at the end of the 1989 season, Erk's Eagles had won three national championship trophies. The legendary coach said he came to Georgia Southern because he and the president were "cut from the same cloth."

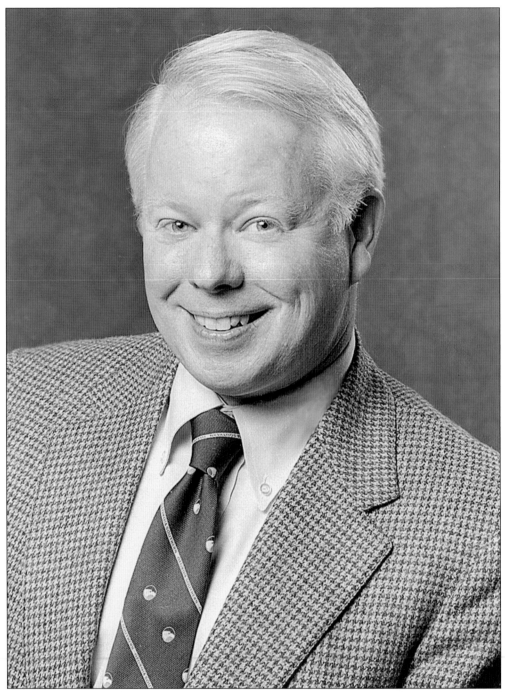

Although he seldom used the "U" word, the 10th president of Georgia Southern was determined to lead the college to university status. Regents approved Nicholas Henry as president at their meeting in the spring of 1987. The former administrator at Arizona State University immediately forged a working relationship with Chancellor Dean Propst. They discussed how the college could develop mutually beneficial relationships with academic institutions in Savannah, Brunswick, and Swainsboro.

Dr. Henry had been on campus for about eight months before his inauguration on the center lawn of the campus, Sweetheart Circle. The theme of the event was academic partnerships. Members of the audience did not realize this was more than an inaugural theme—it was the way Henry intended to pursue university status.

Celebrating the Academic & Partnership
The Inauguration of Georgia Southern's Tenth President

A DESIGNATED INAUGURAL EVENT

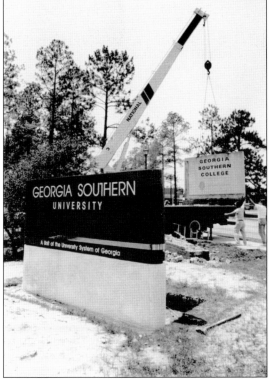

Within a year, President Henry had achieved a goal that had eluded previous leaders for more than 50 years. Key political leadership came from senator and speaker pro tempore Joseph Kennedy of Claxton and influential legislator Terry Coleman of Eastman. The board of regents approved the president's proposal at its September meeting in 1989, effective on July 1, 1990.

During his tenure, President Henry led a continuing physical expansion of the university as enrollment almost doubled to nearly 15,000, a quarter of which were minority students. Observers took note of this unparalleled development in the University System of Georgia. Henry also focused attention on the appearance of the campus and created a "magic mile" of tree-lined sidewalks made of brick pavers.

Few presidents have actually enjoyed dancing as much as Nicholas Henry. He and his wife, Muriel, often took to the floor at campus socials, encouraging the larger university community to join the fun. Often, they entertained faculty and staff, including spouses, at their home.

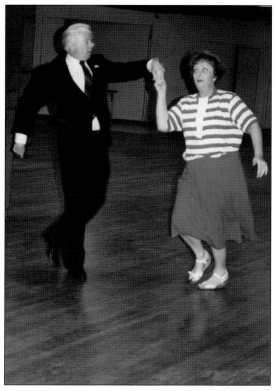

Savannah Morning News cartoonist Mark Streeter interpreted the meaning of President Henry's resignation in 1998. Regional leaders in business and industry had urged Georgia Southern to provide graduates in applied engineering. President Henry had obtained funding commitments to build a new College of Engineering on campus. However, a new chancellor and board of regents failed to approve the undertaking, forcing President Henry to resign. During his retirement, Henry was pleased when regents in 2012 reversed an earlier decision and permitted the College of Engineering at the university.

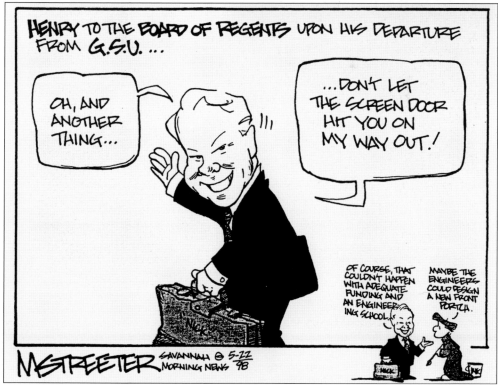

Four buildings bear the names of former presidents Hollis, Pittman, Henderson, and Eidson. After the Bulloch County Board of Education voted to close the laboratory school named for Marvin Pittman in 1998, the university named the Administration Building in honor of the third president. Two obvious changes to the "Ad" Building since Pittman's time are the square porch columns, unlike the original round ones, and the absence of ivy on the brick walls.

The Hollis Building, completed in 1965, honors the first president of the college, who came to the campus in 1920 as principal of the First District A&M School and departed as the first president of Georgia Normal College. Former president Guy Wells, who lived in Statesboro after his retirement, suggested that the academic building should recognize the contributions of Hollis.

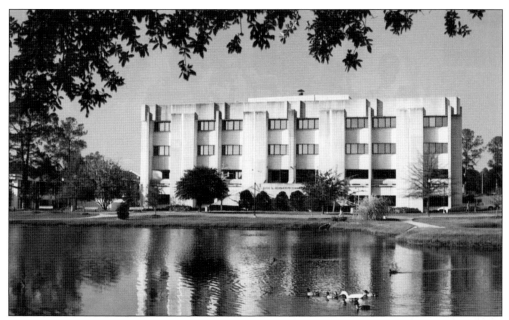

The Zach Henderson Library, shown above, was built in 1975 and had 130,000 square feet of interior space. Between 2004 and 2008, the university almost doubled the size of the library to some 231,000 square feet of space with an automated storage/retrieval system that eliminated some of the traditional book stacks. The new library, shown below, at the heart of the campus, overlooks Lake Ruby.

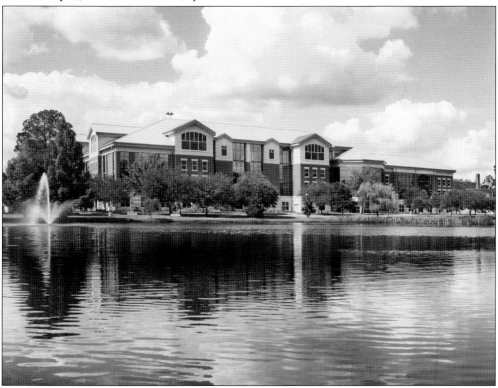

The fourth president to be honored by having a building named for him is President Eidson. President Henderson built the home on campus so that he could be close to his work. John and Perrine Eidson were the second and last to use the president's home as a residence. On April 25, 1995, President Henry dedicated John O. Eidson Alumni House for offices.

Three

ADAPTATION AND CHANGE IN THE PURSUIT OF EXCELLENCE

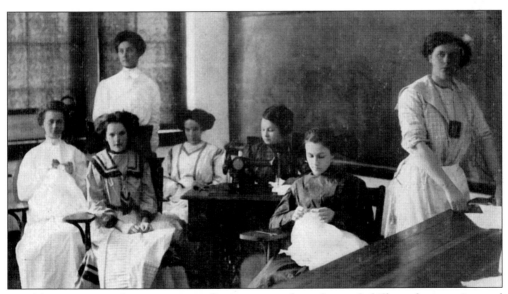

In addition to core classes in arts and sciences, students learned skills such as sewing and clothing design. A standard curriculum for A&M schools included four to five hours daily in subjects of English composition and literature, mathematics (algebra and geometry), physics, chemistry, and natural science (botany and horticulture) and electives in foreign languages, history, and science. The remaining four to five hours were devoted to skills of homemaking for women and farming and mechanics for men.

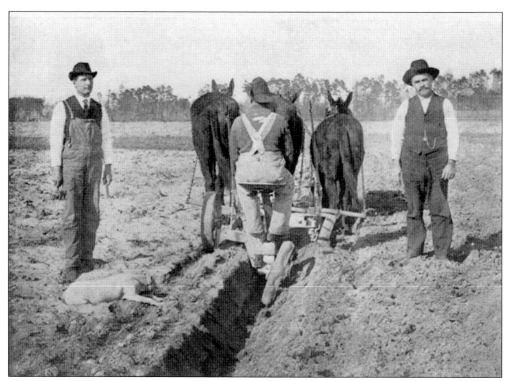

Shown above is Otto Harper (left), a professor who taught agriculture wearing a stiff white collar and tie, suggesting that it was possible to look and act like a gentleman while doing manual labor. He required students to disinfect hoe handles, because common diseases are transmitted through implements. Harper's scientific approach to farming produced results, as in the field of prodigious cabbages shown below.

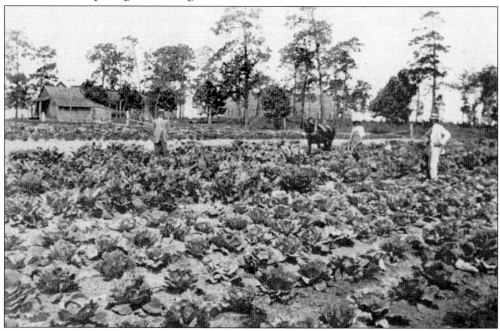

Statesboro valued academics, and several lawyers and businessmen endowed academic medals, including attorney Hinton Booth's annual award in English and the Grimes family awards for general academic excellence for males and females. Congressman Charles Edwards of Savannah also endowed an annual excellence award.

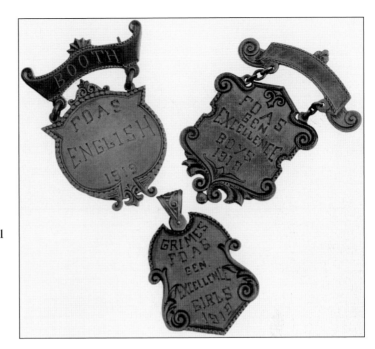

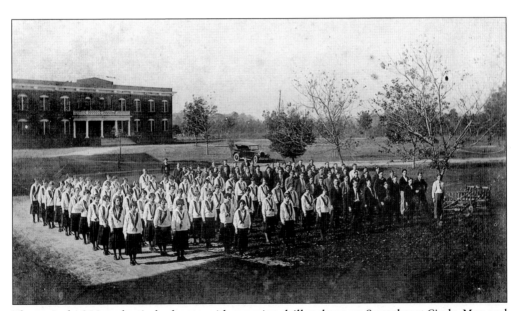

The typical A&M student's day began with morning drill at dawn on Sweetheart Circle. Men and women gathered for light calisthenics and inspection before breakfast. Women wore uniforms (blue bloomers and white blouses with kerchiefs), and men wore jackets and ties.

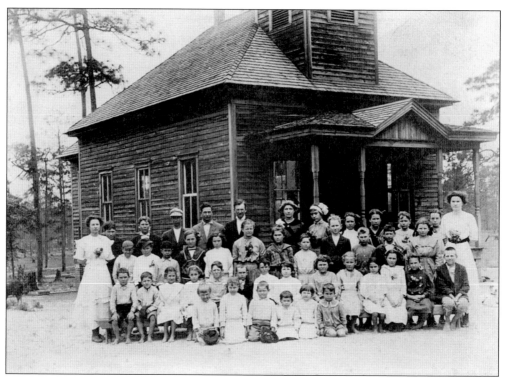

By 1915, the First District A&M offered teachers an opportunity to study subjects beyond the high school level. The response surprised Principal Rowan, and for the next nine years, teachers at one-room schools, like the Sunnyside School in Bulloch County, took courses that improved their subject knowledge and teaching methods. George Aull, an instructor who taught and coached football at A&M from 1918 to 1920, said the school even then was mainly for teachers.

Six years after Aull joined the faculty of Clemson College in South Carolina, the college in Statesboro had a new and innovative president in Guy Wells. He worked out an arrangement with the local board of education to move the one-room Sunnyside School to the campus, where it was renovated into the Sunnyside demonstration school for the purpose of training future teachers.

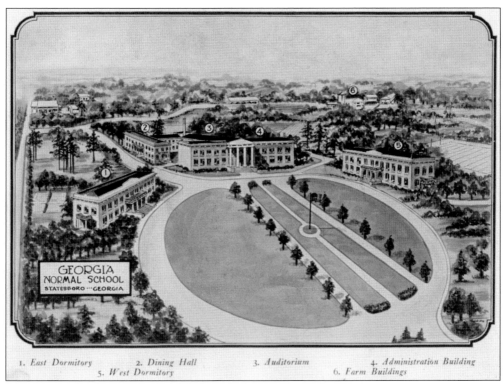

1. *East Dormitory* 2. *Dining Hall* 3. *Auditorium* 4. *Administration Building*
5. *West Dormitory* 6. *Farm Buildings*

An attentive board of trustees replaced Frank Rowan with a principal who was a doctoral candidate at Columbia Teachers College in New York. Within four years, Ernest Victor Hollis transformed the A&M school into Georgia Normal College. Yet, the campus had not changed at all from its A&M days, as the map of the normal school is the same as the A&M school. Hollis did not increase the school's physical plant, but he definitely improved the school's reputation.

The legislature authorized the change of mission in 1924. In a retrospective of 1941, the *Reflector* described the normal school as a place where coeds in bloomers began each school day with calisthenics on the campus lawn. An improved faculty taught classes that prepared teachers for careers in the classroom.

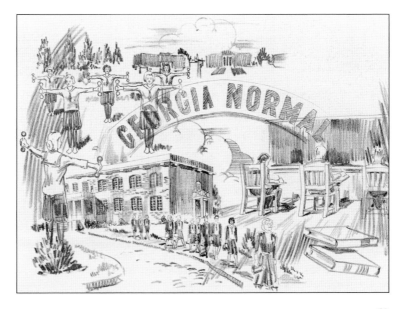

Hollis presided over the transition, but Guy Wells was president for three years of academic changes that enabled the normal school to make a quick upgrade in status to a four-year college. Historically speaking, South Georgia Teachers College was second only to the university in Athens as a state-supported coeducational, four-year college in Georgia. With the new designation, the college changed mechanics to industrial arts and homemaking to home economics, added a range of liberal arts courses, and developed the physical plant to include an Alumni Gymnasium, Health Cottage, an outdoor swimming pool, two lakes, and the Little Store. The college also had its first marching band. This sketch by a student artist appeared in the yearbook *Reflector* in 1941.

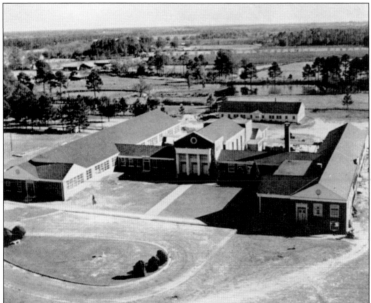

The Laboratory School, constructed in 1937, was a major component of Pittman's plan to improve public schools in the state and nation. He believed that teachers should be competent in the liberal arts and sciences and said a teacher's pedagogical skills should be guided under supervision in a practical classroom setting.

The teachers college applied the progressive educational philosophy of John Dewey and his disciple at Columbia University. A native of White Plains, Georgia, William Heard Kilpatrick (pictured) was a friend of Guy Wells and Marvin Pittman. He visited the campus a number of times between 1930 and 1950.

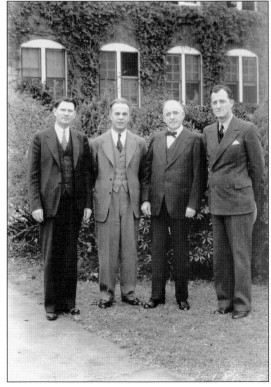

As president of the Rosenwald Fund, Edwin Embree had confidence in Pittman's leadership. Embree described the fund and its objectives at a meeting of educators and community leaders at the college on November 30, 1937. Standing outside the Administration Building are, from left to right, Marvin Pittman, Edwin Embree, Chancellor S.V. Sanford, and J. Curtis Dixon, Embree's assistant at the Rosenwald Fund. Shortly after this visit, the fund's trustees decided to support a new library on campus.

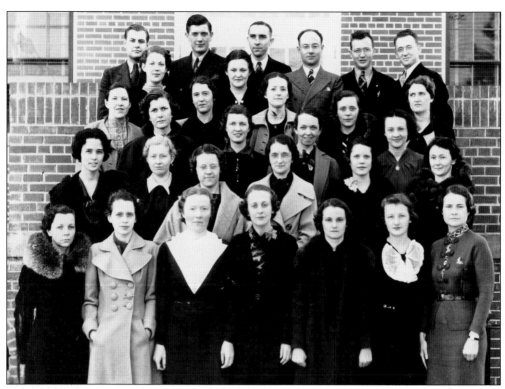

The Rosenwald Club, composed of current and future teachers, practiced the Pittman approach to training teachers. Selected from more than 100 applicants, 30 Rosenwald fellows, locally known as "Rosies," published a newsletter, "The Helping Teacher," and graduates filled important positions in local schools and colleges. The club's first president, Johnnye Cox of Wadley, Georgia, was a faculty member at the University of Georgia who helped develop the state's "Minimum Foundation" legislation; Dr. Thad Hutcherson, a club officer from Hatley, Georgia, was the founding president of DeKalb College in Atlanta. The following other members of the club became educational leaders in Georgia and elsewhere: W.R. Alexander, Miriam Burgess, Myrtle Carpenter, Marianne Castlen, Frances Couey, Mrs. William Deal, Louise English, J.L. Faircloth, Ouida Glisson, Myra Hall, Laura Hargreaves, Harris Harville, Ruby Lois Hubbard, Byrd Ivester, Mrs. Annette Alexander Jones, Lucy McKinnon, M.D. McRae, Jane Quarterman, Ora Lee Roberts, Ruby Sewell, Maude Shaw, Sue Snipes, Marian Townsend, Cherry Waldrop, Mary Webb, Mrs. Jonnie Dickson Welch, Lonnie Lamar Wiggins, and Nell Winn. Professors Kate Hough and Jane Franseth supervised Rosenwald Club members at local schools. (Above, courtesy of the Carol McGahee family.)

The Helping Teacher

PUBLISHED BY THE ROSENWALD CLUB OF SOUTH GEORGIA TEACHERS COLLEGE

| VOL. 1 | COLLEGEBORO, GA., MONDAY, JANUARY 24, 1938 | NO. 1 |

ROSENWALD CLUB SEE WILLOW HILL

Helping Teachers Observe Typical Georgia Negro School Conditions.

THE 1937-38 ROSENWALD CLUB

PITTMAN ATTENDS WASHINGTON MEET

For Third Successive Year President Meets With Rosenwald Group.

In 1958, the board of regents permitted Georgia Teachers College to offer, at first, master's degrees in education. Later, graduate degrees were approved in fields of study, including most departments in the liberal arts and social sciences. The expanding curriculum meant more facilities would be necessary. The first postwar classroom was the Herty Building, pictured here. It was named for the scientist who conducted experiments on the future campus in 1901.

Perhaps the most significant change during the 20 years of the Henderson administration was the reclassification of the college in Statesboro. In December 1959, the board of regents approved the fourth name change in the institution's history to Georgia Southern College. The nickname used for more than 20 years changed permanently from the Professors to the Eagles.

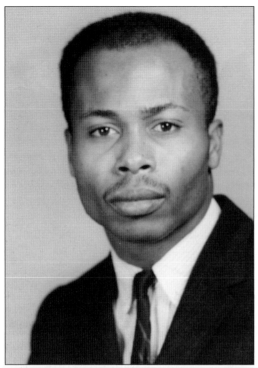

President Henderson, a diplomat by nature, made sure the college did not experience notable controversy during the 1964–1965 school year when the first African American attended classes. Henderson personally escorted John Bradley, pictured here, a music teacher at the all-black William James High School, into the registration line for graduate study. Six African American students enrolled in the fall of 1965. Five of them were women, Clavelia Brinson, Arlene Daughtry, Shirley Woodall, Jessie Ziegler, and Catherine Davis. The male freshman was Ulysee Moseley. During the 1990s, the percentage of minorities reached an historic peak of 28 percent.

By reorganizing the college in 1968, President Eidson made possible the gradual expansion of the college into a university. His experience in higher education encouraged faculty members to operate as though they were teaching at a university. Eidson believed that having more international students would enrich the college, and he appointed a foreign student advisor, Dr. Harris Mobley, who began an international initiative. Pictured in 1971 is the first international club.

In the 1980s, the campus changed as new majors entered the curriculum. Reserve Officers' Training Corps (ROTC) began as an extension of a Mercer University program in military science and quickly established itself as a major academic area at Georgia Southern. This program, initiated by President Lick, has grown into a significant component of learning for both women and men.

Rural health care, an early initiative of President Lick, has been a major success at the university. The College of Nursing has developed into a respected program that attracts some of the best students in the field. The program's focus on an underserved population has been a major factor in the university's positive reputation in Georgia and across the nation.

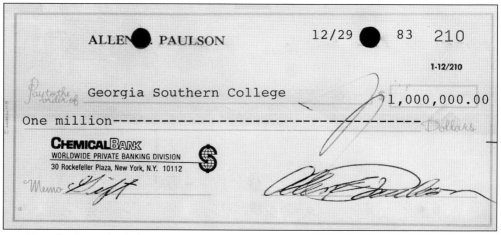

In 1983, the first check from the president of Gulfstream Aviation was the largest gift to the college from an individual. The public generally considers Allen Paulson as the major sponsor of the football program. He admired coach Erk Russell, his staff, and his team. As Paulson learned about the varied academic programs at the university in the 1990s, he actively supported the science, technology, and engineering programs several times the amount of his initial donation to Eagles football.

On July 1, 1990, the brand-new university stood alone among Georgia's colleges, having exceeded requirements for advancement. Alumni of the 20th century especially realize the significance of this transition. Georgia Southern president Nicholas Henry accentuated the achievement when he called on a friend from Arizona, Supreme Court Justice Sandra Day O'Connor, to deliver a major address that celebrated a new university in the fall of 1990. Many students regarded her talk as the most important event of their college career.

Four

MOVERS AND SHAPERS
OF THE FUTURE

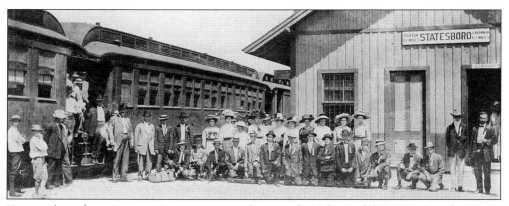

New students from Screven County arrive at the train depot located downtown on the corner of East Main and Railroad Streets around 1909. A mule-powered omnibus transported them to the new First District A&M School on the hill just south of town.

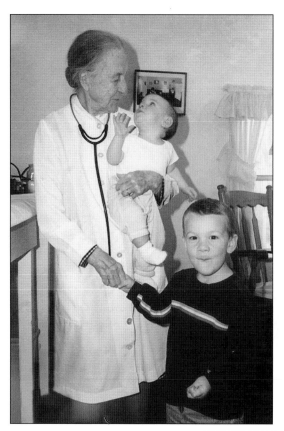

Leila Daughtry completed her high school curriculum at the A&M school in 1918. She fondly recalled that her job at A&M was in the dairy, where she specialized in separating cream from milk. In 1922, she graduated from Bessie Tift, a Baptist women's college in Forsyth, Georgia. When she attended the Medical College of Georgia in the 1920s, she was the only woman in her class. The pediatrician was active in her career until she retired at the age of 103 in 2001 (left). When she died in 2012 at the age of 114, she was one of the oldest living persons in the world. Dr. Leila Daughtry-Denmark worked primarily at the Children's Hospital, affiliated with Emory University in Atlanta. Emory awarded her an honorary doctorate. In 1989, Emory installed a memorial in her honor in a garden outside the Egleston Children's Hospital (below).

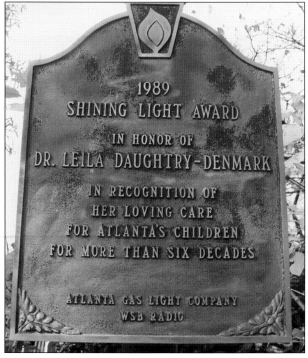

Dan Bland grew up on a farm near the A&M school. An avid inventor and tinkerer, even as a student, he developed a steam-powered pump. He said he enjoyed attending the school where he improved his knowledge of farming, machinery, and life in general. He and his wife, Catherine, deeded their farm and botanical gardens to Georgia Southern University upon their deaths. Today, the property is known as the Garden of the Coastal Plain.

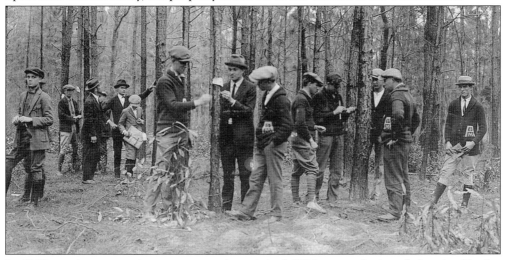

In 1912, students examine trees near the original 1901 research site of chemist Charles Herty. Located on the northeastern side of the campus, many of these trees remain in the same location more than 100 years after the students examined trees for bark changes and possible beetle infestation. Agriculture and horticulture teacher Otto Harper was responsible for maintaining a healthy forest.

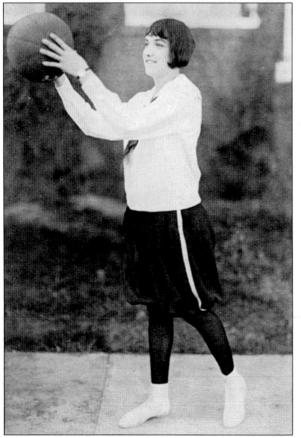

This rule-breaking episode of cigarette smoking probably unfolded at Little Lotts Creek on the south side of the A&M school. Bertha and Ida Mae Hagins donated the photograph to the Georgia Southern University Library in 1997. Four Hagins sisters, Bertha, Louise, Ida Mae, and Dell, studied at the A&M school between 1912 and 1923. Neither Bertha nor Ida Mae wished to identify the names of those involved in the forbidden activity.

True Watson plays basketball in her physical education class. She wears clothing required of female students at the A&M school and Georgia Normal College: dark blue bloomers and white top with a blue or black kerchief. Watson grew up in Metter, Georgia.

Huldah Cail (top of formation), a gymnast and dancer from Sylvania, enjoyed leading cheers at football games in the late 1920s. Her husband, George Burford Lorimer, an editor and author who died in 1952, developed Millhaven Plantation north of Sylvania in the 1940s. The Lorimer Reading Room on the fourth floor of the university's library is named in his honor. She donated this photograph to the Special Collections of the Henderson Library.

President Wells hired two popular adjunct faculty members and paid them by providing free board and lodging during the Great Depression. First came Byron Dyer, a Bulloch County agricultural special agent, who lived in a room on the unfinished top floor of the men's dormitory. Later, the president hired Dyer's new bride, Martha, as the women's basketball coach and physical education teacher. The students liked the popular young couple. Both were recent graduates of the University of Georgia.

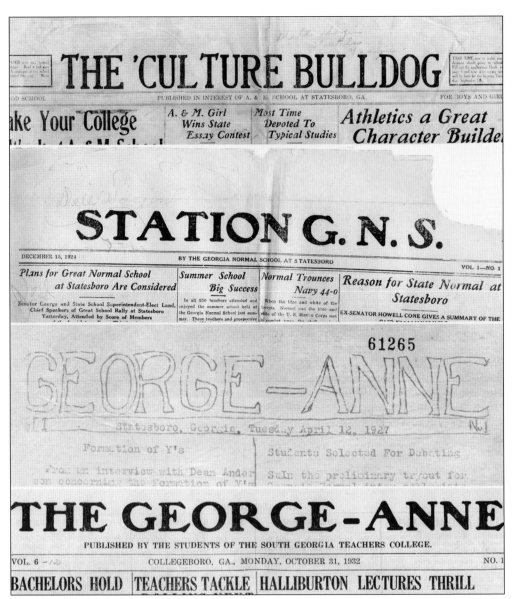

THE 'CULTURE BULLDOG

PUBLISHED IN INTEREST OF A. & M. SCHOOL AT STATESBORO, GA.

FOR BOYS AND GIRLS

ke Your College

A. & M. Girl Wins State Essay Contest

Most Time Devoted To Typical Studies

Athletics a Great Character Builder

STATION G. N. S.

DECEMBER 15, 1924

BY THE GEORGIA NORMAL SCHOOL AT STATESBORO

VOL 1—NO. 1

Plans for Great Normal School at Statesboro Are Considered

Senator George and State School Superintendent-Elect Land, Chief Speakers of Great School Rally at Statesboro Yesterday, Attended by Score of Members

Summer School Big Success

In all 250 teachers attended and enjoyed the summer school held at the Georgia Normal School last summer. These teachers and prospective

Normal Trounces Navy 44-0

When the blue and white of the Georgia Normal and the blue and white of the U. S. Marine Corps met in combat upon the athletic

Reason for State Normal at Statesboro

EX-SENATOR HOWELL CONE GIVES A SUMMARY OF THE

61265

GEORGE-ANNE

Statesboro, Georgia, Tuesday April 12, 1927

Formation of Y's

From an interview with Dean Ander son concerning the formation of Y's

Students Selected For Debating

Sain the preliminary tryout for

THE GEORGE-ANNE

PUBLISHED BY THE STUDENTS OF THE SOUTH GEORGIA TEACHERS COLLEGE.

VOL. 6

COLLEGEBORO, GA., MONDAY, OCTOBER 31, 1932

NO. 1

BACHELORS HOLD | **TEACHERS TACKLE** | **HALLIBURTON LECTURES THRILL**

The student newspaper, known since 1927 as the *George-Anne*, began as *The 'Culture Bulldog* in the early days of the A&M school. Students preferred the unique name 'Culture (shortened form of Agriculture), but after the upgrade in status to Georgia Normal School in 1924, the new name was *Station GNS*, chosen because of the popular new medium of radio—it did not stick. In 1927, the journalism professor, Robert Donaldson, encouraged students to select a name, and they chose one that has endured.

The yearbook, the *Reflector*, began in 1927 and ended in 1989 when it became a magazine. The origin of the name is distinctive to the campus. In 1927, and for years later, a reflecting or gazing ball stood on a pedestal near East Hall, the women's dormitory. It was near the edge of the road leading to Anderson Dining Hall adjacent to the Administration Building.

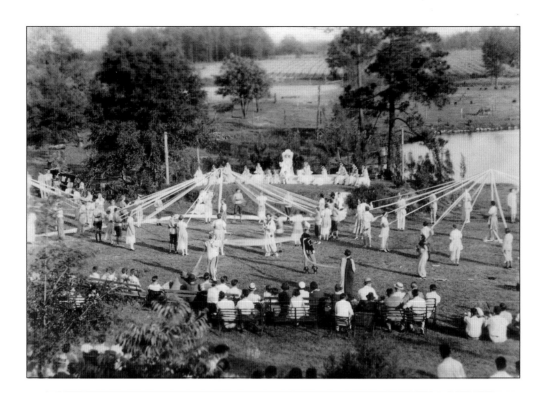

In 1927, President Wells transformed the annual spring field day into a memorable May Festival, a tradition that continued for two decades. The key event was the crowning of the queen of May after an interpretive dance depicting the struggle between winter and spring. Many students participated in the culminating maypole dance. The first May queen, Bernice Lee, appears below with her maid of honor, Lolale Fountain. *Bulloch Times* editor David Turner described the inaugural event on May 5, 1927: "No more beautiful picture has ever been seen than that presented by this event on the open lawn of the school, in which pretty girls dressed in most charming attire portrayed the crowning of the queen after the battle between winter and spring in which spring was the victor. Graceful dancing and beautiful costumes made a most pleasing picture."

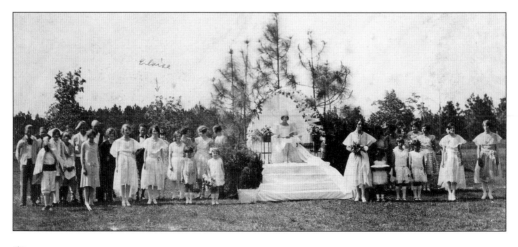

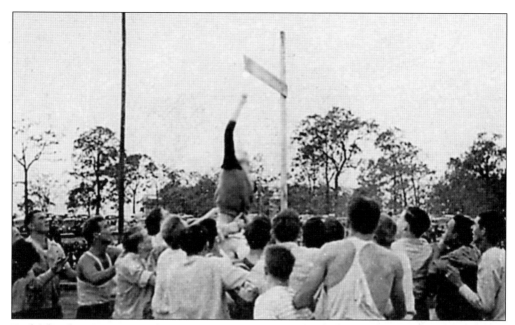

Each Thanksgiving Day in the 1920s and 1930s featured an important football game at noon. On Friday, sophomores, juniors, and seniors could visit friends and family for a long weekend, but the freshman class could not have the holiday unless they captured the flag from the upperclassmen. The upperclassmen often won because they knew how the game was played. Occasionally, however, freshmen captured the flag and enjoyed an off-campus holiday.

Parades on Thanksgiving morning and at Homecoming featured colorful floats and races of bathtubs-on-wheels. A perennial favorite in the late 1930s was a student's jalopy called the "Air Flow Taxi." On this parade day, campus humorist William Gesmon Neville Jr. ("Dippy Dutch" and "Slats Segram") kidnapped the housemother of the men's dorm, Sophie Johnson, and she endured the indignity of riding the entire parade in Neville's bizarre mode of transportation.

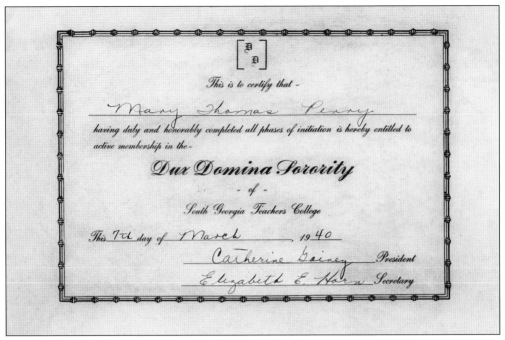

This is to certify that -

Mary Thomas Perry

having duly and honorably completed all phases of initiation is hereby entitled to active membership in the -

Dux Domina Sorority

- of -

South Georgia Teachers College

This 7th day of March, 1940

Catherine Dairey, President

Elizabeth E. Horn, Secretary

Before 1968, the college would not permit nationally affiliated fraternities and sororities. Local social clubs like Iota Pi Nu (IPN) existed to organize dances and social occasions throughout the year. Members of Dux Domina were, as the name suggests, "leading ladies." John King, a native of Jeff Davis County, met his future wife and *Reflector* yearbook beauty queen, Mary Thomas Perry of Screven County, at an IPN dance. (Courtesy of the King family.)

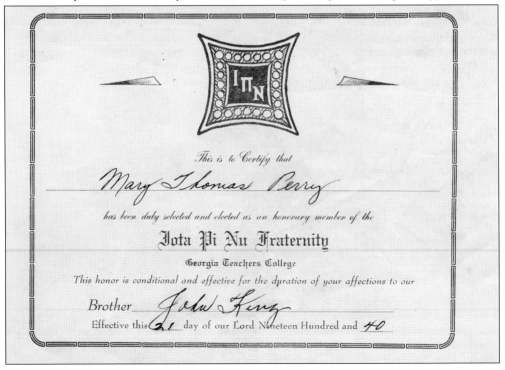

This is to Certify that

Mary Thomas Perry

has been duly selected and elected as an honorary member of the

Iota Pi Nu Fraternity

Georgia Teachers College

This honor is conditional and effective for the duration of your affections to our

Brother *John King*

Effective this 21 day of our Lord Nineteen Hundred and 40

Though John King was only a member of a local fraternity, his fraternity's jewelry was still high quality with pearls and gems. Of course, King did not wear this one for long, because he gave it to his sweetheart, Mary Thomas Perry, who was "pinned" to him. They married after their college days at South Georgia Teachers College. (Courtesy of the King family.)

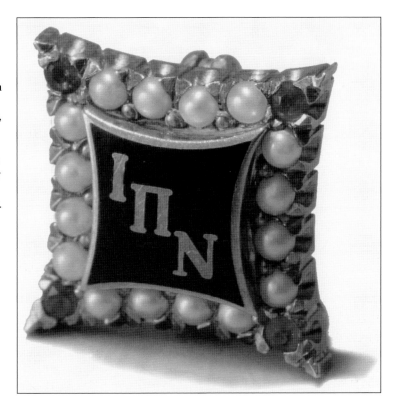

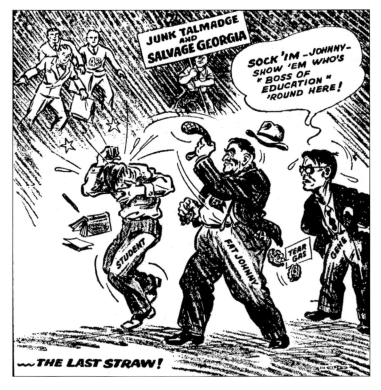

When the governor fired Marvin Pittman as president of Georgia Teachers College, students responded by conducting peaceful demonstrations against the governor. This cartoon in the *Bulloch Times* on August 10, 1941, is about a demonstration in Statesboro that Talmadge henchman "Fat Johnny" tried to turn into a riot for publicity purposes. The public, however, saw through the antics of the governor's heavy-handed aide.

As a result of political interference, enrollment plummeted at Georgia Teachers College. Many male students enlisted in the armed forces to defend a nation in World War II (1942–1945). Fewer than 200 students, mostly women, remained at the Statesboro college. The college rented a dormitory, the dining hall, and other facilities to the US Army's Strategic Training Assignment Reclassification (STAR). The campus newspaper, fully staffed by females, featured articles about "Star-gazing" and "Dancing with Stars." These officers-to-be appreciated the abundance of female attention.

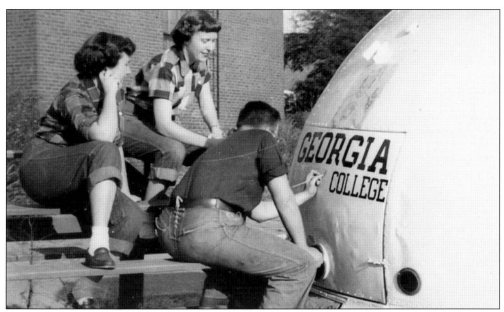

George Parrish was an excellent student who earned a place in *Who's Who in American Colleges and Universities*. Like many Georgia Teachers College students in the late 1940s and early 1950s, he felt a keen sense of loyalty to the institution. A budding artist, Parrish painted attractive signs, including the Georgia Teachers College bus identification under the watchful eyes of Anne Trice Middleton (left) and Gay Kimbrough Dull. He studied with one of America's best illustrators—Norman Rockwell. Parrish drew historical murals and posters for magazines, movie studios, and board games. Students remember his clever sketches that appeared in the *Reflector*, especially the carefree couple in front of a campus landmark, the Little Store (below).

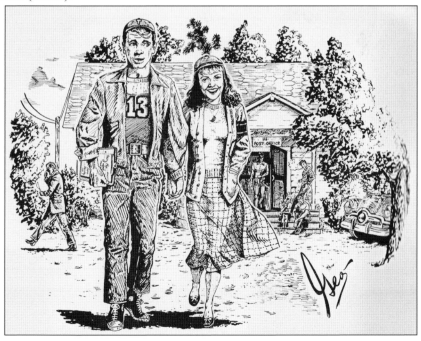

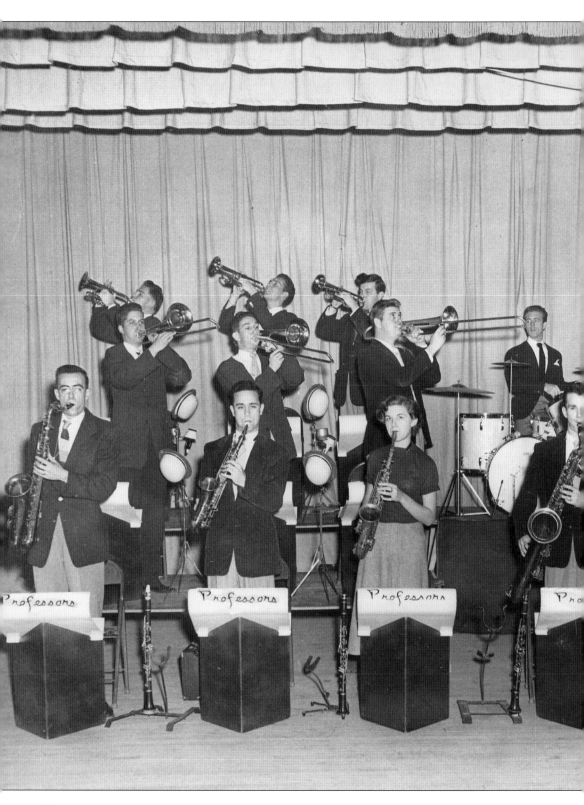

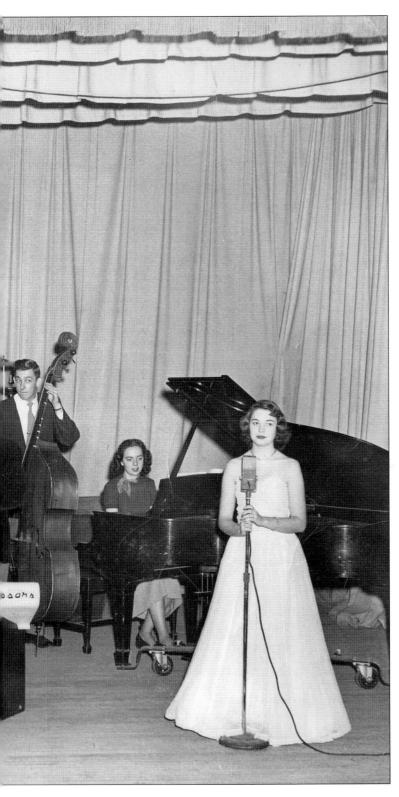

During and after World War II, big band music was popular, such as the music of Glenn Miller, Benny Goodman, and the Dorsey Brothers, Jimmy and Tommy. A vocalist rendered lilting melodies about moonlight and romance. Music instructor Dana King led the Professors, a popular group locally and regionally. The vocalist pictured with her band mates is Jo Starr. From left to right are saxophonists and clarinetists Bill Brown, Eddie Ort, Faye Lunsford, and Rudy Mills; trombonists Dale Bush, Chester Pool, and Bobby Humphrey; and trumpeters Bobby Taylor, Sonny Hawkins, and bandleader Dana King. Bert Justice is on the drums, Morris Davis is plucking the bass, and Marjorie Weathers graces the piano keyboard.

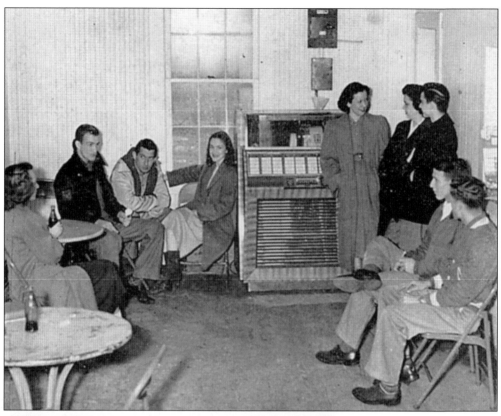

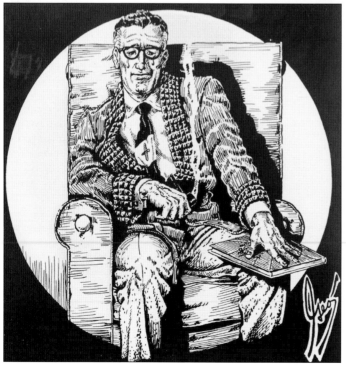

Veterans of World War II enriched the student population in the late 1940s and early 1950s. They took a break from their studies at 9:00 p.m. on weekday evenings, enjoying a Coke and swapping stories at the Blue Tide. Gathered around the jukebox, they listened to the latest hits while catching up on both news and gossip. These are moments that alumni of the 1950s fondly remember. Cartoonist George Parrish combined humor and pathos in this speculative illustration of how students of the postwar generation would recall events such as this in future years.

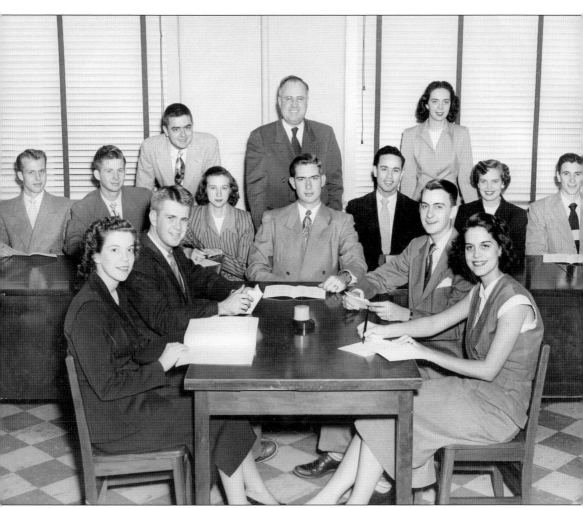

In 1951, the Georgia Teachers College Student Government met regularly to enforce standards of academic behavior and to seek ways to improve campus communication. Students considered their election to this body to be both an honor and a responsibility. Pictured from left to right are, (seated at the front table) Juliett Oliver, Dan Biggers, Spencer Overstreet, Billy Moore, and Charlotte Crittendon; (seated at the rear table) Watson Weathers, Alvin Moreland, Blair Wells, Eddie Ort, Yvonne Jones, and Jimmy Oliver; (standing) Walter Durden, Dean Paul Carroll, and Marjorie Weatherford.

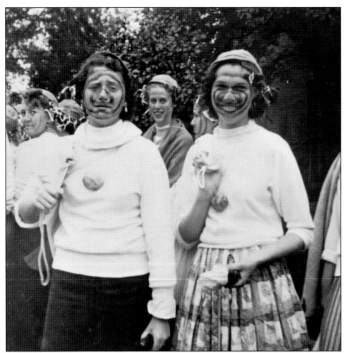

Jane and Joyce Jackson were rats in the 1950s when freshman initiation was at fever pitch. They had to paint a bull's-eye target on their faces. They wore skirts upside down and blouses backwards, and they practiced walking backwards up the steps of buildings. Male students also suffered indignities at the hands of upperclassmen, such as being forced to parade around campus in the evening clad only in underwear. By 1966, the initiation into the freshman year had disappeared completely here and on most American campuses.

Mose Bass retired as the custodian for West Hall, Sanford Hall, and Cone Hall in 1967. He had served the same college with four different names: Georgia Normal School, South Georgia Teachers College, Georgia Teachers College, and Georgia Southern College. Only President Henderson could boast of serving the institution longer than Bass. More than a custodian, he was a trusted counselor and friend of generations of students. Those who slept late were familiar with his "Get up, Baby!"

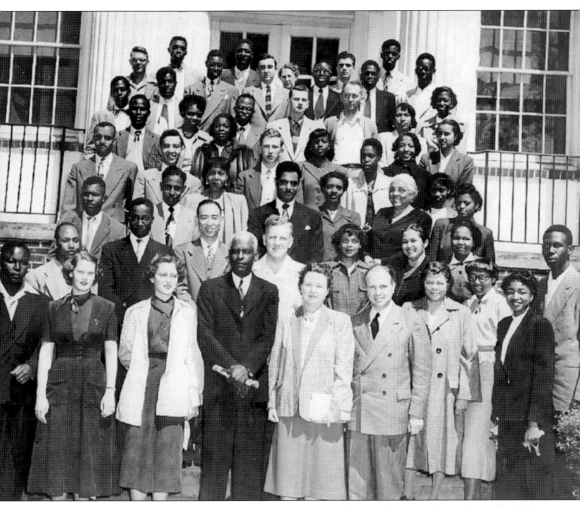

China Altman grew up in Waycross, Georgia. As a student, she served on the staff of the campus newspaper, the *George-Anne*. After she graduated with honors in 1954, she began a long career in journalism and was one of the early female overseas correspondents with United Press International. In 1951, acting contrary to the advice of the president of Georgia Teachers College, she attended a controversial but inspiring interracial meeting at Paine College in Augusta. In this photograph, she is third from the left in the first row. Standing next to her is the noted educator, author, and civil rights pioneer, Dr. Benjamin Mays, the president of Morehouse College in Atlanta.

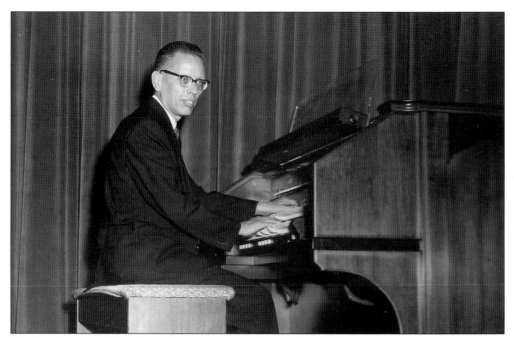

Dr. Jack Broucek (above) taught organ and piano at the college. His easygoing manner as a professor and his spirited performance at the organ during basketball games won the hearts of the student body. He organized the Organist Guild to support music students who aspired to be organists, many of whom enjoyed successful careers as church musicians. Dr. Broucek invited Richard Elsasser (below, at the organ), a world-renowned organist, to appear at the college as a guest of the guild. Around Elsasser are, from left to right, Margie Jackson, Marjorie Weatherford, Billy Moore, Jackie Knight, Gilbert Hughes, Joyce Vaughn, Dr. Jack Broucek, Betty Ann Sherman, and Martha Driscoll.

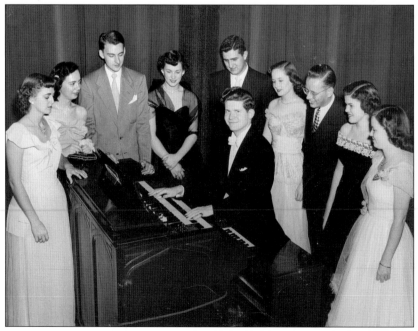

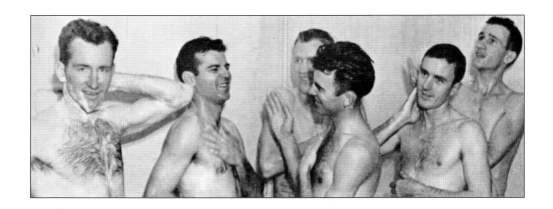

This was an era of communal living. Men were accustomed to sharing showers (above). Dorm residents in the 1940s through the 1960s experienced the camaraderie of dorm life. Guys (below) threw an impromptu party, featuring Cokes for 14 friends in 1955. They are, in various order, Joe Ed Green, "the Pulaski Flash"; Johnny Mallard; Fred Pierce; Marvin VanOver; Hollis Ray Powell; Hal Griner; Harvey Lee Simpson; Bob Bonds; Ralph Parsons of Kentucky; Harry Strickland; Bill Evans; Clarence Taylor; Jerry Silverman; Ed Mitchell; and Sonny Clements.

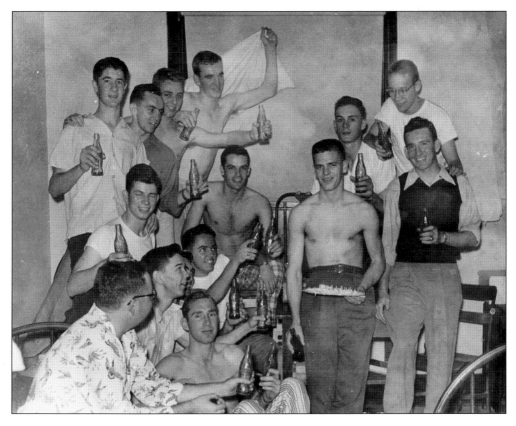

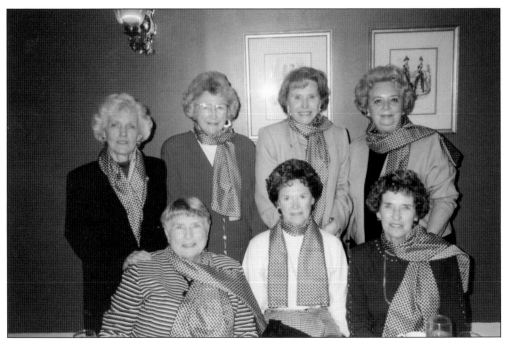

Among alumnae, no bond is stronger than a shared youth that each one uniquely remembers. The "T.C. Girls," who graduated in the early 1950s, gathered periodically, and they renewed their friendships each time. Posing for the camera in 1997 are, from left to right, (sitting) Anne Trice Middleton, Dottie Aycock Kergan, and Betty Lewis Mitchell; (standing) Allene Timmerman Haugabook, Maxine Corbitt Wilson, Gay Kimbrough Dull, and Marjorie Weatherford Hern. (Courtesy of Gay Kimbrough Dull.)

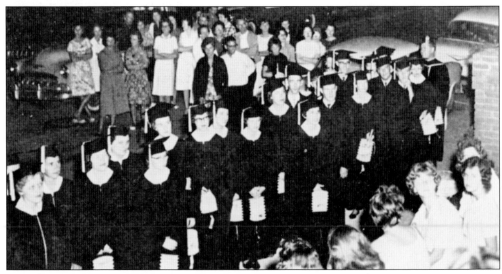

The Lantern Walk, a campus tradition, began in 1935 on the eve of spring commencement. Wearing academic regalia, seniors stand on Sweetheart Circle, which is illuminated only by lights of the seniors' lanterns. The group stops at several buildings on the circle, and a senior speaks to the class about the history of the structure and events associated with it. The walk ends with a reception at the Administration Building.

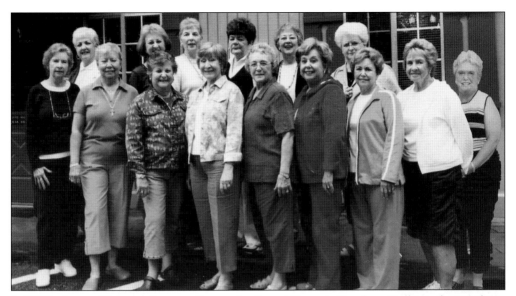

In 2013, almost 60 years after meeting each other at Georgia Teachers College, the Southern Belles still get together more than once each year. They are, from left to right, (first row) Hannah Pope Kent, Jenny Mitchell Howsare, Mary Alice Taft Greene, Frankie Bland O'Brien, Carol Goff Russell, Sandra Tindol Franklin, Barbara Branch Wilkinson, and Carolyn Davis; (second row) Sandy Hanson Griffin, Nita Freeman Doss, Sandra Wiggins Stange, Liz South Penny, Ellan Brandon Jolly, Jane Jackson Highsmith, and Sylvia Gurganus Harris. (Courtesy of Jane Jackson Highsmith.)

Statesboro native, Georgia Southern alumna, and the first lady of Georgia Betty Foy Sanders (far left) arrived at the Statesboro airport with her husband, Georgia governor Carl Sanders. Donald McDougald, owner-manager of radio stations WWNS and WMCD-FM, interviewed the governor, who later advocated the re-election of US president Lyndon Johnson in an address to a packed McCroan Auditorium on October 19, 1964. In his introduction to the governor, college president Zach Henderson said, "Governor Sanders has given Georgia the name of a progressive state."

The long-delayed but always-expected university in Statesboro received new impetus at the parade in 1965. With the future as the theme of homecoming, the event encouraged a service fraternity, the Alpha Phi Omegas, to build a float anticipating Georgia Southern University in 1970, exactly 20 years before the board of regents approved the change in status.

Wisely, the administration permitted a student entertainment committee to select performers they enjoyed. Year after year, beginning in the late 1950s, the students scheduled an amazing array of musical groups. Georgia Southern in the 1960s and 1970s hosted major acts, including Ike and Tina Turner, Simon and Garfunkel, and Otis Redding. Appropriately, a "long-haired" group from England made its first visit to an American college campus at Georgia Southern. The Rolling Stones (above) took the stage at Hanner Gymnasium on May 4, 1965. A popular group, Georgia's own Mother's Finest (below) wowed the student body in 1978 with spirited instrumentals and vocals.

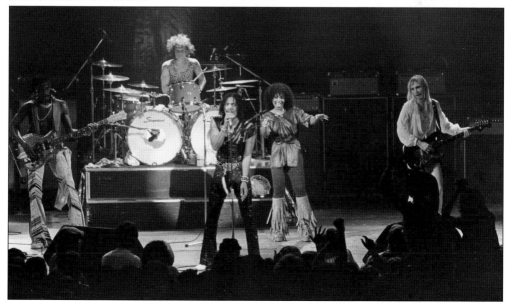

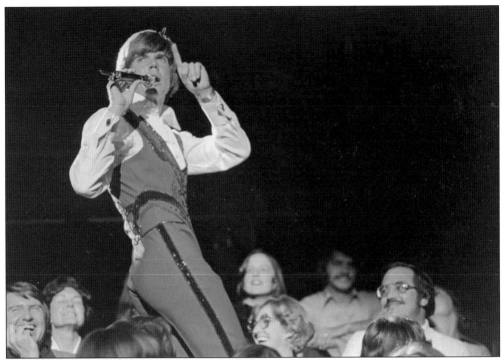

One of the largest audiences to see a singer and television personality locally onstage showed up at Hanner Fieldhouse in the late 1970s. Singer John Davidson captivated the audience with a rendition of popular songs and an engaging routine. The audience seemed astonished and thrilled as Davidson interacted with them.

Automobiles slowed to a snail's pace from the 1960s through the 1980s to allow drivers to observe a beach scene on Sweetheart Circle. The coeds turned the center of Sweetheart Circle into a popular location for sunbathing, particularly during the spring. The popularity of tanning beds in the 1990s lured sunbathers away from the beach towels and ended a memorable tradition.

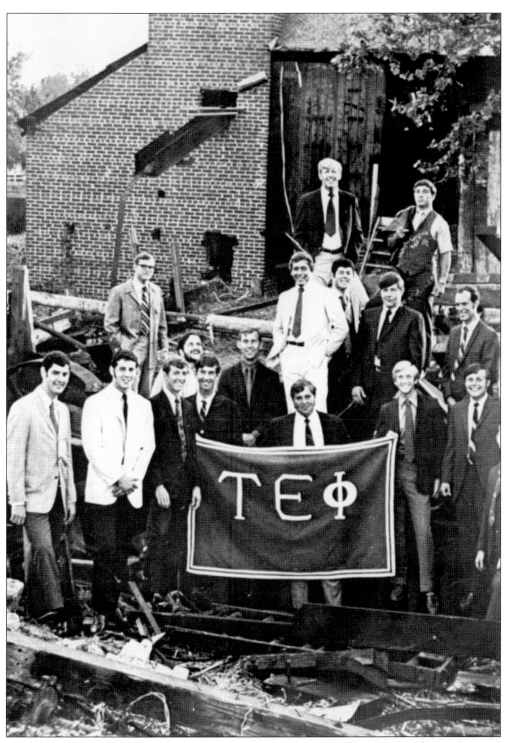

Until the coming of new president John Eidson, no nationally affiliated social fraternities and sororities were permitted on campus. During 1968, students organized Greek colonies (six sororities and 13 fraternities) preliminary to full membership that began in 1969.

Although Greek organizations were new to campus, they adopted some customs that have a long history. For example, Rat Week each autumn traditionally ended with a huge tug-of-war between "rats" (freshmen) and upperclassmen. The losers would be pulled into Lake Wells. For a number of years, this tradition continued during Greek Week in springtime. As strange as it may seem, initiation into Greek organizations compensated for the absence of tension and hilarity of Rat Week. Just as in days of old, the losers always end up in the water.

Georgia governor Jimmy Carter and his wife, Rosalynn, participated in the Homecoming parade in downtown Statesboro in 1972. Later in the day, he spoke to the students and faculty on the campus. The youthful farmer from Plains, Georgia, was elected as the 39th president of the United States in 1976 and later won the Nobel Peace Prize—the only president in history to do so after serving in office.

At the first national Earth Day on April 22, 1970, Michael Segers (second in line) poses as an acolyte for a mock funeral processional in memory of Mother Earth. An English major from Sylvester, Georgia, Michael worked for an international literary organization in New York after he graduated from Georgia Southern College. Then, he taught English and Spanish in his hometown high school for 20 years.

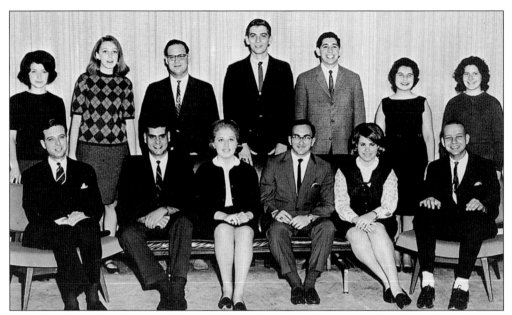

Jewish students have been members of the student body from its earliest days, but there was not an organization for members of this faith and culture until 1966, when the Hillel Club was formed. From left to right are (first row) Allan Pollard, vice president Steve Myers, treasurer Claire Halpern, president Ron Baruch, secretary Charlet Lind, and advisor Dr. Robert Boxer; (second row) Martha Haimovitz, religious chairwoman Marilyn Rosenberg, Jerry Michaels, Sandord Nichosson, Robert Stein, Janet Fox, and Irene Cohen. Not pictured is advisor Dr. Nathaniel Shecter.

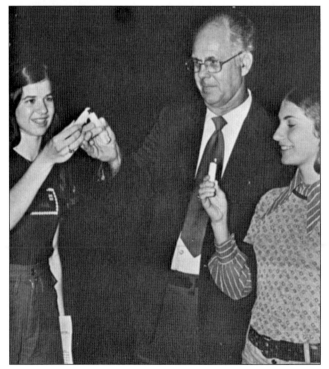

The Reverend Nathan Byrd became the first full-time director of the Baptist Student Union in 1967. He enjoyed participating in the annual Christmas tree-lighting ceremony held traditionally in early December. For many years, the great oak tree in front of the Williams Center was festooned with lights during the holidays. The deterioration of the aged tree caused the university to relocate the ceremony to Sweetheart Circle.

Five

THEY CAME HERE TO PLAY AND TO LEARN

"Victory is always sweet," Byron Lambert "Crook" Smith shared with the *George-Anne*, "but victory without sportsmanship, loyalty, and courage is not worthwhile." Smith coached winning teams in football, basketball, baseball, and track, beginning in 1929. His greatest teams, he said, "were composed of young men of high character who had courage, conviction, and manhood to stand up for the . . . fair and square thing. To this type of athlete, I attribute our success." A "five-star" athlete at Mercer, he was the brother of legendary running back Phoney Smith. Coach Smith was disappointed to see football vanish as a team sport during World War II.

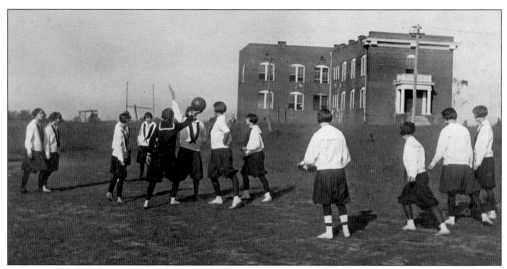

The athletic field was located behind West Hall (later Deal Hall) during the first two decades of the college. Girls preferred basketball above all other sports. Called the Farmettes, the girls' team had a reputation for their tenacity and shooting ability.

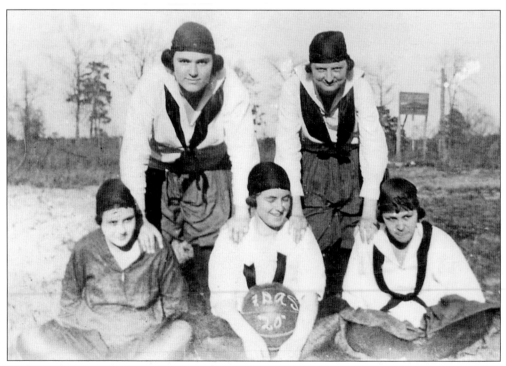

Ruth Smith (center, first row) and Bertha Hagin (far right, second row) were notable basketball players for the 1920 First District A&M Farmettes. The players wore both skullcaps and game faces for competition, and they usually played well.

Charlie Gibson, a native of LaGrange, Georgia, was an all-around athlete and excellent debater who helped the A&M school excel both in sports and in literary meets. He transferred to the Polytechnic Institute at Auburn, Alabama, where he excelled in football. After playing professional baseball, he returned to the Auburn area, where he was an esteemed high school coach and teacher.

Coach Esten Graham Cromartie of Statesboro was an early coach of men's and women's athletic teams. A debonair individual who dressed well for all competitions, Cromartie was popular with players, both male and female. Cromartie also taught agriculture.

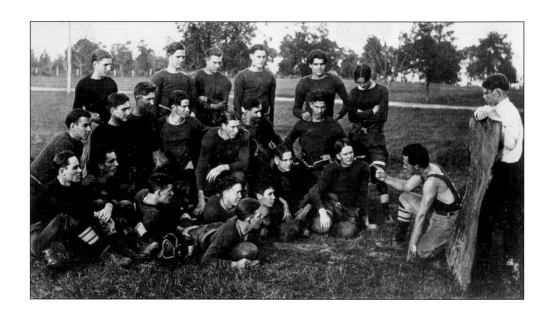

The football team above listens as the coach explains how to run the single-wing formation using a makeshift chalkboard. The first football practice was in 1909, and the A&M team competed against schools in nearby towns in 1910 and 1911. This undated photograph might be from the early 1920s. The coach might have been Mark Anthony, "the noblest Roman," a famous football player from the University of Georgia who coached the team in 1923. The team below appears ready to compete after practicing on the campus circle.

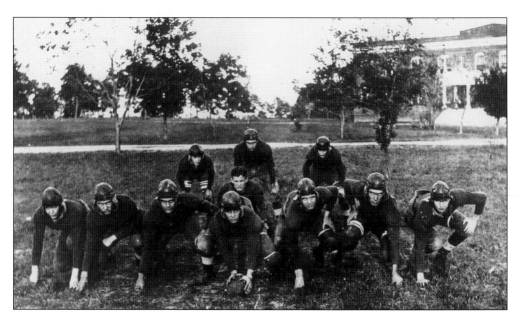

This baseball team probably played Augusta on Saturday, April 17, 1915. Whatever the sport, the 'Culture was a distinctive and popular nickname. According to Bertha Hagin, who attended the school in 1918, some students called it "Dah 'Culture." The nickname continued to be popular, even after the A&M school became Georgia Normal School in 1924. Students were slow to give up 'Culture for "Blue Tide." When the legislature approved South Georgia Teachers College in 1929, the nickname finally was put to rest, and everyone eagerly pulled for the "Teachers."

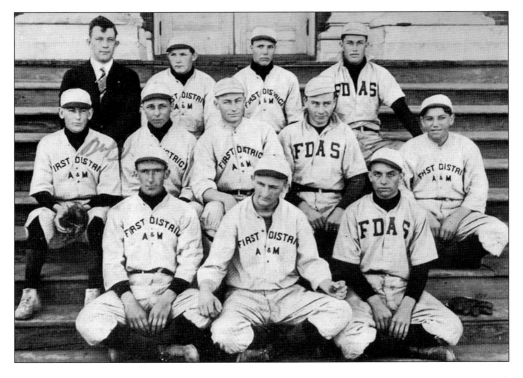

Joe Lambright, who graduated in 1935 and settled in Savannah, shows the perfect stance for a pulling guard in the single wing formation. The pads were lightweight and the helmets flimsy, but the players were enthusiastic about teaching opponents a thing or two about the game of football.

During his first year as coach, Crook Smith (fourth row, second from left) led the team to a state college championship in 1929. College president Guy Wells (fourth row, fourth from left) strongly identified with the team that represented South Georgia Teachers College.

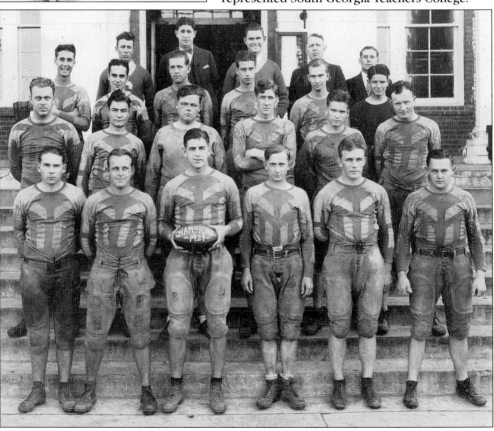

Jake Hines of Statesboro compiled records as a fleet-footed halfback in football. He was outstanding in baseball as a hitter and error-free second baseman. In basketball, he was the leading scorer. Coach Smith said, "Without a doubt, Jake Hines was the greatest athlete in the history of the college."

Sportswriter Morgan Blake followed the game of football closely and wrote about it convincingly for the *Atlanta Journal* in the 1920s and 1930s. Upon reviewing the play of Earl "Coonie" Riggs, Blake wrote, "Old number 5 is one of the greatest centers we have seen."

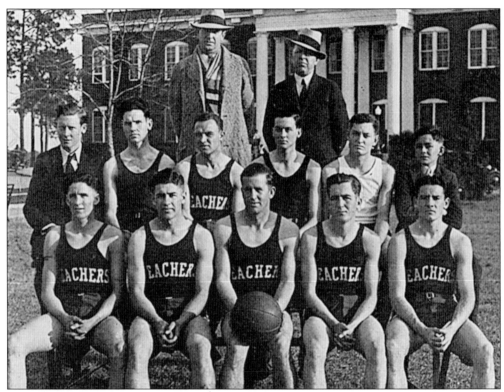

Conference basketball champions in 1931, coach Crook Smith (left) and President Wells stand proudly behind the team. Members are, from left to right, (first row) George Hagin, Jack Thompson, J.D. Fields, Clyde Greenway, and Edward Jones; (second row) Ray Bell, Oscar Joiner, B.C. Olliff, Bobby Sasser, Elton Sanders, and James Carruth (manager). Because the college did not have a gym on campus, the team practiced and played in Statesboro's empty tobacco warehouses and in the armory downtown. President Wells and each faculty member donated one month's salary to build a gymnasium in 1932, called the Alumni Building, the fifth major building on the campus.

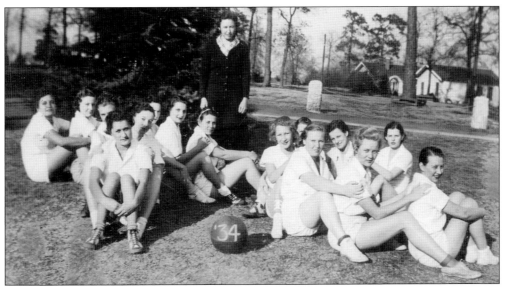

The *George-Anne* in January 1934 reported: "This promises to be a thrilling time for all basketball enthusiasts on campus. Mrs. [Martha] Dyer is acting as coach and the girls practice from four to six each afternoon. The clubs, societies, and sororities also are practicing and have planned a tournament to begin January 25th."

In 1929, just as the Great Depression began, college president Guy Wells announced a series of campus improvements that added to the quality of student life. Without state funding or major donations, he built two lakes on the backside of the campus using labor provided by the Bulloch County Commission. He promised male students that if they donated an hour a day to excavate a swimming pool, they could enjoy it for the rest of their years at the college. The outdoor swimming pool was a source of pleasure for many generations of students until the end of the 1960s, when the college built an indoor pool.

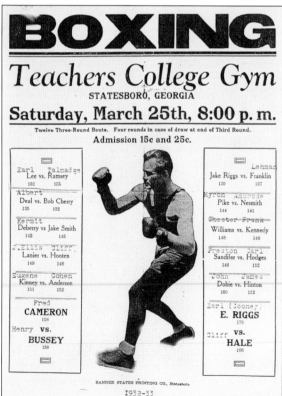

BOXING

Teachers College Gym
STATESBORO, GEORGIA

Saturday, March 25th, 8:00 p. m.

Twelve Three-Round Bouts. Four rounds in case of draw at end of Third Round.

Admission 15c and 25c.

Earl Talmadge	Lehman
Lee vs. Ramsey	Jake Riggs vs. Franklin
132 135	130 137
Albert	Myron Ambrose
Deal vs. Bob Cherry	Pike vs. Nesmith
135 132	144 141
Kermit	Chester Frank
Deberry vs Jake Smith	Williams vs. Kennedy
142 143	148 146
J.Ellis Cliff	Preston Earl
Lanier vs. Hooten	Sandifer vs. Hodges
149 146	148 152
Eugene Cohen	John James
Kinney vs. Anderson	Dobie vs. Hinton
151 152	150 152
Fred	Earl (Cooney)
CAMERON	**E. RIGGS**
158	176
Henry **vs.**	Cliff **vs.**
BUSSEY	**HALE**
158	166

BANNER STATES PRINTING CO., Statesboro

1932-33

Fielding Russell studied the "manly art of self-defense" at the University of Georgia. In 1933, as a young English professor at South Georgia Teachers College, he began introducing hundreds of students to the discipline of boxing. Some student boxers, including Chester Williams, participated in matches held downtown. The boxing class ended in 1938 when Coach Russell took a leave of absence to enroll in graduate school.

Boxing matches held at the new alumni gymnasium on campus attracted local competition. Every contestant listed on the match sheet is from the campus or from the city of Statesboro. This competition called for 12 three-round matches, with a fourth round (a tiebreaker) if necessary. While Henry Bussey and a few others were local businessmen and farmers, most boxers were students of Dr. Russell.

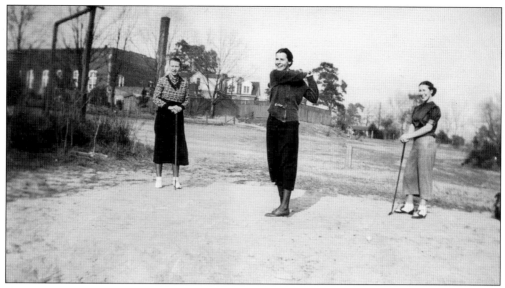

Physical education professor Caro Lane (left) introduces student Mary Margaret Blitch to the game of golf at a nine-hole course on the south side of the campus. Faculty member Elizabeth Donovan watches as the novice golfer prepares to hit the ball. Later, the course was moved to the north side of the campus near the entrance to the college.

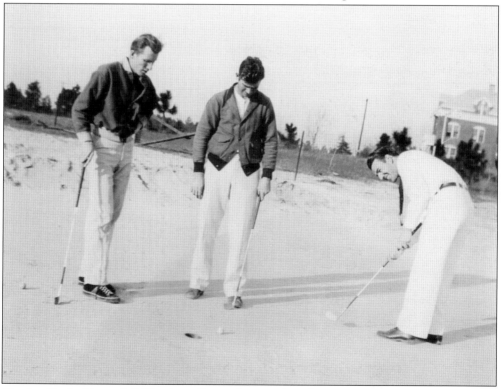

Charles Shafe (class of 1933), the college's first student from Canada, putts the ball on the first hole that conspicuously is not a "green" but a "white," as in sand. The lack of some of the finer features of the game did not take away the fun of competition.

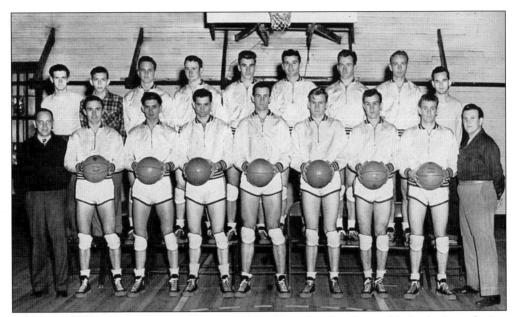

In 1947, James Boyd "J.B." Scearce began a new era in local college athletics by introducing a basketball program that emphasized speed and play making. The legendary first postwar basketball team members are, from left to right, (first row) J.B. Scearce (coach), Charlie Wireman, Frank Bagley, Tom Dykes, Jerry Connor, Mitchell Conner, Jimmy Connor, Herb Reeves, and "Lard" Greene (manager); (second row) Jack Murphy (manager), Billy Carter (manager), "Bulldog" Adams, George Lindsey, George Eanes, L.D. Bowen, "Rhed" Prosser, "Bo" Whaley, and Cliff Hill (manager).

Atlanta Constitution sportswriter Furman Bisher called the five-foot, three-inch Scearce "The Littlest Prof." Bisher wrote that Scearce began the initial practice each season by holding up a round object and saying, "Men, this is a basketball." From 1947 through 1980, he won 396 games and lost 225 for a winning percentage of 0.638.

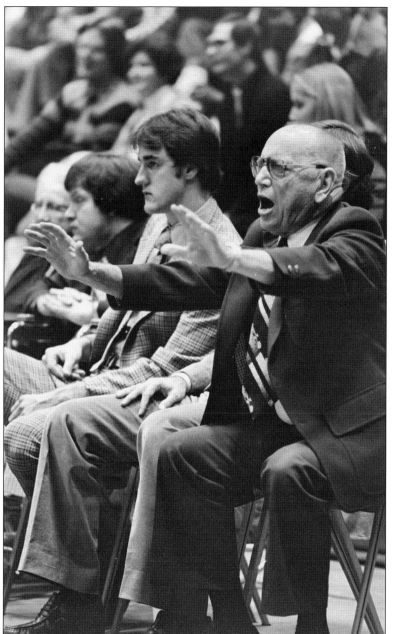

In 1947, Coach Scearce dispelled the longing for a revitalized football program because his basketball team compiled an 18-3 record during his first year. During the next two decades, players like Scotty Perkins, Chester Webb, Sonny Clements, Fran Florian, and others helped the Professors defeat big-name teams in the South.

THE GEORGE-ANNE

PUBLISHED BY STUDENTS OF GEORGIA TEACHERS COLLEGE

CONGRA-TULATIONS PROFS

VOLUME 33 COLLEGEBORO, GEORGIA, FRIDAY, DECEMBER 4, 1959 NUMBER 10

Professors Open Season With Bang, Whip Georgia 82-73

"Blithe Spirit" Given
As Year's First Play

By TOM COFFEY
Savannah Morning News Sports Editor

Chester Curry and Eddie Owens formed a two-pronged scoring punch that knocked the University of Georgia for an 82-73 loss here Wednesday night as Georgia Teachers College kept intact a four-year record of winning its basketball season opener.

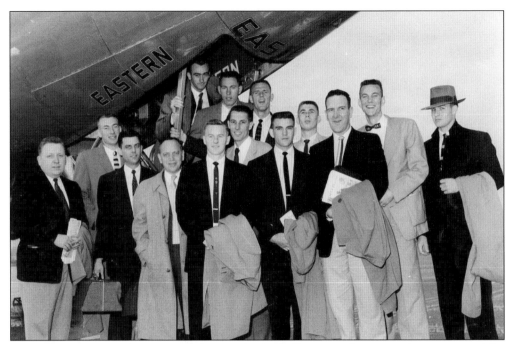

A small passenger airplane carried the 1955 basketball team to the national tournament. The three players standing on the stairs of the plane are, from left to right, Garland Campbell, Bo Warren, and Don Avery. Standing below them are, from left to right, announcer and publicist Joe Axelson, Doug Corey, a *Savannah News* reporter, coach J.B. Scearce, Buddy Ward, Chuck Livaney, Don Wallen, Jim Harley, Buster Cartee, Chester Webb, and Emory Clements. (Courtesy of the Chester Webb family.)

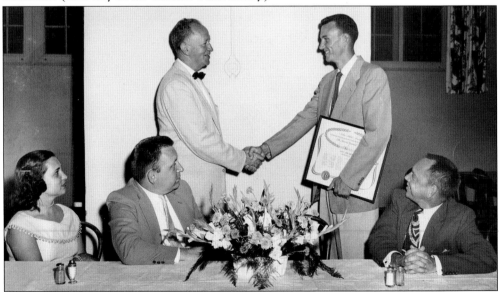

For both 1955 and 1956, Chester Webb, a student from Elberton, Georgia, was named an All-American; President Henderson, who played basketball at Piedmont College, presents the All-American Award for 1955. Also pictured are, from left to right, Rae Axelson, Joe Axelson, and coach J.B. Scearce (Courtesy of the Chester Webb family.)

Frank Kerns coached the Georgia Southern Eagles from 1981 until 1995. In 14 years, his teams compiled the best record statistically in basketball history at Georgia Southern with a 0.649 (244 wins and 132 losses) winning percentage. His teams won three conference championships and represented Georgia Southern at three NCAA and two National Invitation Tournaments.

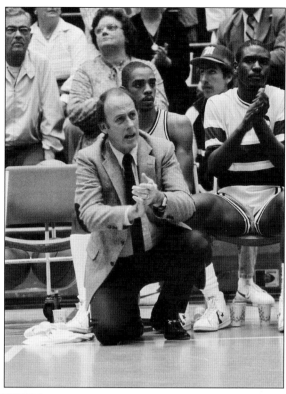

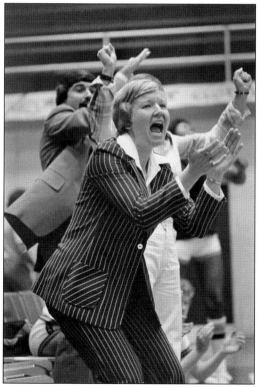

Inducted into the Georgia Southern Athletics Hall of Fame in 1990, Linda Crowder was an outstanding player who also served as a coach. In 1978, she coached the Lady Eagles the way most great coaches do—she was totally immersed in the game.

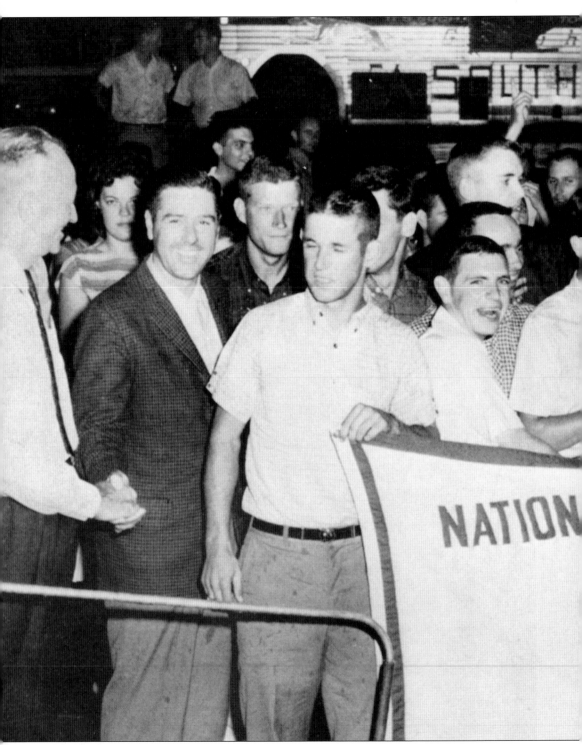

The College World Series champions of 1962 returned home by bus on the evening of June 11. Dozens of cars gathered to meet and escort the team home on US Highway 80 West at Hopeulikit, about 10 miles from the college. With blaring horns and blinking headlights,

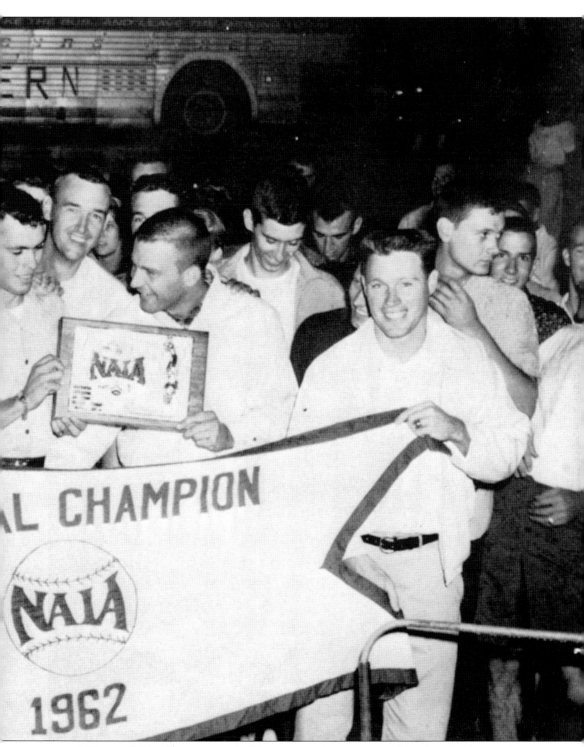

ecstatic fans and friends accompanied the team to the campus, where hundreds eagerly met and celebrated with the coach and players that night and early morning. College president Zach Henderson met the team and congratulated Coach Clements (far left).

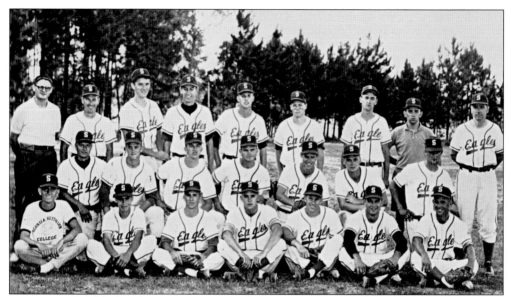

The Eagles of 1962 were the first Georgia Southern team to win a national championship. One of many heroes on the team was pitcher Pierce Blanchard, who won back-to-back games, including a shutout in the final game of the College World Series. Pictured are, from left to right, (first row) Roy Stewart, Larry Maurer, Pierce Blanchard, E.G. Meybohm, Larry Crouch, David Bell, and Clyde Miller; (second row) Denny Kline, Jackie Raley, Mike Johnston, Bill Griffin, Charles Tarpley, Tommy Howland, and Don English; (third row) Don Gale (trainer), George Cook (assistant coach), Mike Keasler, "Chico" Jones, Mickey Allen, "Buzzy" McMillan, Miller Finley, Robert Budd (manager), and coach J.I. Clements.

Baseball coach Ron Polk came to Georgia Southern in 1972 and, in four years, revitalized a traditionally strong sport. When he left to begin a sensational career at Mississippi State at the end of the 1975 baseball season, his record was impressive: 155 wins and 64 losses. After leading the Eagles to the College World Series in 1973, he almost repeated the trip in 1974—the season of the "streak" of 20 straight wins. Not since 1962 had Statesboro and the student body been so enamored with baseball.

Jack Stallings spent 36 years coaching collegiate baseball; the best 23 of those years were at Georgia Southern (1976–1999). A win-loss record of 1256-799 during his career placed him among the elite coaches in the nation. Known as a "teaching coach," Stallings led the Eagles to four appearances in the NCAA tournament. In 1990, his team played in the College World Series. In 2005, the university named the playing field in his honor.

In 1971, Georgia Southern funded a major collegiate golf tournament named in honor of sports broadcaster Chris Schenkel. Today, the E-Z-Go Schenkel Invitational is a premier tournament for college golfers. Chris (left) and Georgia Southern University public relations director Ric Mandes are seen reminiscing about Schenkel's days at the college in Statesboro when he participated in the Army's STAR program (see page 72).

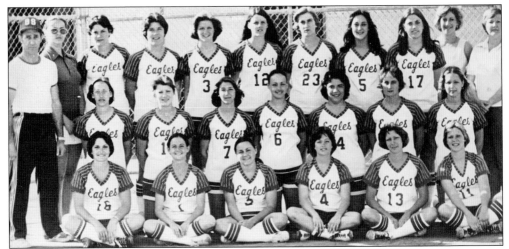

Dr. Bill Spieth began his softball coaching career in 1972 as a volunteer, and his first team made it to the regional of the national tournament in Tallahassee, Florida. Members of the legendary team included, from left to right, (first row) Kim Preston, Linda Garner, Sandra Smith, Barbara McCoy, Jan Glass, and Suann Colson; (second row) Peggy Johnson, Barbara Kilmer, Stephanie Brown, Ann Bryant, Debbie Ellis, Cindy Franklin, and Phyllis Smith; (third row) coach Bill Spieth, manager Dawn Crabbe, Anne Clarke, Alicia Gallagher, Patti Brown, Susan Lee, Cathy Stewart, Shelia Brock, and Beverly Lentz.

Members of Georgia Southern's first men's swim team are, from left to right, Mark Kyle, Bret Patterson, Bill Schmidkey, Rick Crowell, Skip Carrol, unidentified, Bubba Mitchell, Jody Summerford, Henry Haywood, manager Bruce Walters, and coach Gordon "Buddy" Floyd. Although the nonscholarship team lost every meet during its first year, Coach Floyd's Eagle swimmers quickly became competitive.

The college was fortunate to find Pat Yeager, formerly a coach for US Olympic gymnasts, to begin Georgia Southern's gymnastics team in the early 1960s. He quickly developed a powerhouse squad. Yeager coached a team that no Southeastern Conference school could manage to defeat.

On its way to the National Association of Intercollegiate Athletics (NAIA) finals in 1965, the men's gymnastics team defeated handily major universities, including Virginia (90-50), Georgia Tech (77-65), Auburn (105-35), and Georgia (99-43). From left to right are Kip Burton, John Peacock, Ronald Tyre, Arnold Murphy, Larry Merritt, Joe Lumpkin, John Latimer, Charles Eunice, John Prentice, Charles Williams, Buddy Harris, Jimmy Allen, Richard Bowden, Jere Hook, Ronnie Mayhew, and Bill Aldrich. Not pictured is Sammy Williams.

Pictured here is Coach Oertley's team of 1974. After Coach Yeager left Georgia Southern for a career in Texas, Ron Oertley continued the winning tradition in gymnastics until the program was dissolved within a decade. From left to right are coach Ron Oertley, John Gracik, David Zirnsak, Dan Warbutton, Bobby Rick, David Davis, Yoshi Taki (the 1970 US Amateur Athletic Union all-around champion), and Bill Tollifson.

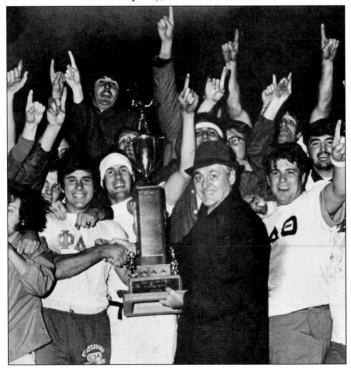

Jubilant members of the Phi Delta Theta fraternity celebrate their status as the number-one football team. Recent vice president and now president Pope Duncan presents the championship trophy for intramural flag football to the Phi Delta Theta team for 1971. The tournament began in November and ended in early December. During his presidency, Dr. Duncan assumed that the college never would have an intercollegiate football team.

Men's and women's cross-country teams experienced a rebirth under the leadership of psychology professor Daniel Nagelberg from 1982 to 1985. Pictured are, from left to right, (first row) Rhonda Elrod, Ruth Weaver, Robert Frisk, and Tony Mixon; (second row) Terri Rucker, Christi Daprano, Kelly McCormick, and Matt Jasinski; (third row) Johan Dolven, coach Daniel Nagelberg, Hans Wittrup, and Tim Roundtree. Sean McCormick guided the teams in their first official season as members of the Trans America Athletic Conference (TAAC) and the New South Women's Athletic Conference (NSWAC) in 1985. Each year, the teams grew stronger. In 1989, the women's team won the runner-up trophy of the NSWAC. In 1992, Jim Vargo, an Olympic qualifier, became head coach, and the teams continued to improve. A former Eagle runner, Brad Simmons, was the last men's and women's coach in 1996.

Fencing became a strong sport on campus, as well as in the state, because biology professor Dr. Frank French loved it. He created a cadre of fencers who shared his commitment. Even though fencing was never a part of the athletics department, the college gladly permitted the team to practice and compete at campus facilities. Dr. French, a model fencer, demonstrates the stance "en garde."

Conversations with friends and alumni at annual Homecoming events typically included laments about the absence of football at the college. From left to right, Bill Winn, Cohen Anderson, and George Hagins, former athletes, encouraged President Lick to explore the potential market for football in an area of the state that college football had been absent since 1942. Hagins, a star player, is a member of the Georgia Southern Athletics Hall Of Fame.

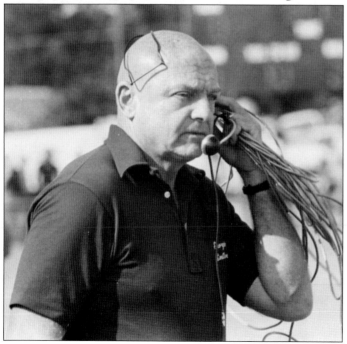

Coach Erskine "Erk" Russell identified with the historic Georgia Southern attitude immediately. While he had been a defensive coordinator at the University of Georgia when it won the national championship game in 1980, he relished the challenge of starting a team from scratch. He knew he would work with a small budget at first. His attitude was that "when you do not have the best of everything, you learn to make the best of everything you have."

Coach Erk Russell found uncanny ways to motivate his players and a growing base of fans in southeastern Georgia. Playing mostly club teams in 1982, such as the Fort Benning Doughboys, was serious competition, and the fans rejoiced in victories, even at this level of competition. Various ideas emerged as candidates for the Eagles' mascot. This effort in 1982 was a crude prototype of the Eagle Gus that emerged within the next decade.

The victories all began in 1981 at Womack Field, where the Statesboro High Blue Devils play football, and continued into what Russell called "the prettiest little stadium in America." When he retired in 1989, the Georgia Southern brand was solid, and Big Blue seemed poised to move to the highest level of competition. The Georgia Southern band was reorganized and reinvigorated, and its halftime shows at the high school stadium proved it was, as the coach said, "the best darned band in America."

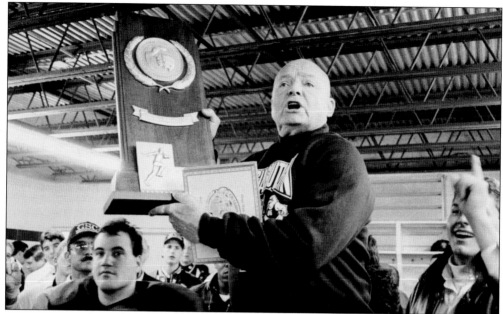

Between 1985 and 2000, the Georgia Southern Eagles won six national championships in Division I-AA of the NCAA. Erk Russell's teams won the first three; teams coached by two of his former assistants, Tim Stowers and Paul Johnson, won the next three, with Stowers at one win and Johnson two.

At the end of Adrian Peterson's collegiate career in 2001, Georgia Southern fans showed their appreciation for No. 8, who set six school records as a running back. Peterson won the Walter Peyton Award during his sophomore year. After graduation, he played for the Chicago Bears until his retirement.

While Georgia Southern faculty members worked to establish higher standards in academics and athletics, President Lick formed a committee to develop a new logo and motto. The result is a neat logo that continues to represent the institution's academic and athletic endeavors. The motto, "Academic Excellence," gradually fell out of use. Perhaps a reason for this change is that "excellence is excellence, wherever you find it—in the classroom or on the playing field," as some coaches and professors have said.

The football program, like the university, has grown larger since 1981, but Eagle Nation does not forget the one who started it. A statue at the stadium features the likeness of Erk Russell, who forever overlooks the Eagles' field of dreams—even when it is covered with snow in December.

When the air is warm and the grass is green in the month of May, proud families fill Paulson Stadium. From near and far, they come to see their sons, daughters, and loved ones march across the stage to commence the journey toward their destinies. Georgia Southern's mission is to prepare them with knowledge, discipline, and skills they need for that journey. Great coaches of the 20th century used different words to say the same thing: athletic competition is not an end in itself, but it is a reminder of the noble mission of this university.

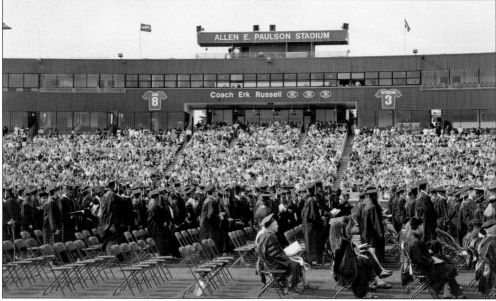

Six

A CAMPUS TO REMEMBER

A couple in 1976 takes a study break at the head of the lake President Wells built in 1932. Unknowingly, they enjoy the shade of the Bonaparte willow, an offspring of a willow that sheltered the grave of Napoleon Bonaparte. In 1932, Mae Michaels, secretary to President Wells, asked her sister Moina to obtain a few cuttings while she was in Europe to visit Flanders Fields. "President Wells has a green thumb and can make anything grow," wrote Mae to her sister. Moina complied with her sister's request, and in 1933 Wells successfully planted this historic tree on the eastern bank of Lake Wells. Earlier, he had cultivated and transplanted dozens of live oaks that began as tiny acorns and, during the next century, became mighty oaks. The Bonaparte willow's offspring seedlings may be found on the campus today near Lake Wells and Lake Ruby. Cuttings of this historic willow also were cultivated in London, England, by the Royal Kew Gardens.

Guy Wells (1926–1934), the president and inveterate planner, wanted the campus at Collegeboro to have distinction. The leader, who described himself as a nonintellectual, said his role was to build a campus where intellectuals would be respected. Toward that end, he built solid community support and gave himself to the task of making the campus landscape memorable. At the center, he planned and built two lakes, first a small one (pictured) and then a larger one. Today, the lakes are central to this naturally beautiful campus.

With Lucien Lamar Knight, the official historian of the State of Georgia, President Wells identified four historic trees in Georgia and planted their offspring on the Collegeboro campus. They are the Oglethorpe oak (Darien), the Wesley oak (St. Simons), the Lanier oak (Brunswick), and the "tree that owns itself" (Athens). He perpetuated a legacy of live oaks and indigenous plants that President Henry and his successors have honored.

Seen in 1982, the grounds around the smaller Lake Wells show no signs of improvement since the 1930s. Heavy foot traffic exposed the prevalent white sandy soil. Students from several dorms walked the path to the library and to classes in the Carroll and Newton Buildings. Before 1987, the college received little funding for buildings and grounds.

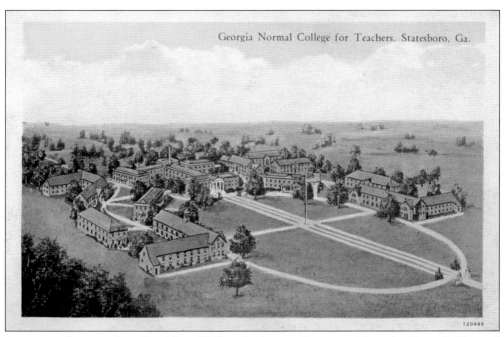

Georgia Normal College for Teachers. Statesboro, Ga.

A master of promotion, President Wells asked an artist to envision the Georgia Normal College for Teachers of the future. Fortunately, the campus did not develop in the crowded manner depicted in this postcard. Wells himself is responsible for establishing a plan that took advantage of the uncrowded landscape.

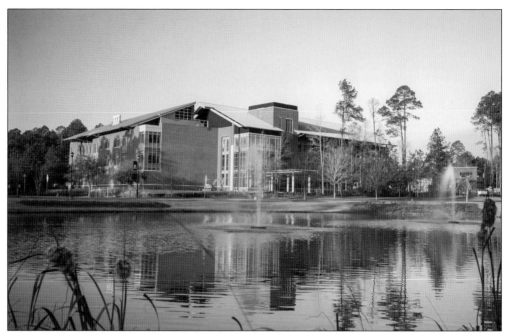

After Georgia Southern became a university in 1990, President Henry organized planning sessions with engineers and architects. The result is a set of general guidelines for the architecture of buildings and the landscape. The style of new structures should resemble regional architecture, including porches, brick walls, and metal roofs. An example is the Biological Sciences Building nearing completion in 2013 (above). Landscaping should build on the best of the past: spacious lawns with winding tree-shaded paths of brick pavers that lead to buildings with inviting spaces inside, like renovated Brannen Hall (below).

In 2008, Bruce Grube, shortly before
he retired as president, authorized
a team of architects and planners to
develop a Campus Master Plan for
Historic Preservation. The important
document of 371 pages lists all
campus buildings and landscape
features. Grube (at right) and his
committee suggested improvements
and changes to existing buildings.
They documented 29 sites on the
campus that qualify for inclusion
in the National Register of Historic
Places. The committee recommended
these places be considered as legacies
from the past. A particularly attractive
building is Rosenwald Building,
(above) constructed in 1938 by
Statesboro contractor and architect
Walter Aldred.

The College of Engineering and Information Technology, completed in 2001, was the first stand-alone information technology college in the University System of Georgia. The idea for the college originated during a dinner conversation in 1997 that involved Michael Dell, Georgia governor Roy Barnes, and state representative Terry Coleman. Graduates of the college serve businesses and industries that depend on digital communications and innovative technologies.

After Lake Wells proved to be a successful and inexpensive project in 1932, the president asked the Bulloch County Commissioners to provide prison labor to complete a second, larger lake. Students called the first lake simply "Wells" for the president, and they chose the second name to honor the first lady of the college, Mrs. Ruby Wells. Today, Lake Ruby continues to dominate the landscape at the heart of the campus.

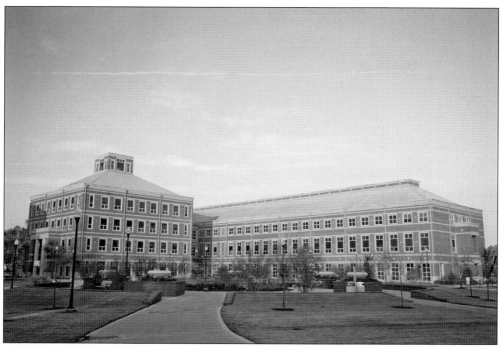

Constructed according to building guidelines of the late 20th century, the College of Education resembles a traditional schoolhouse. It overlooks a freshwater pond at the intersection of Akins Boulevard and Forest Drive.

The College of Business Administration is almost halfway down President Henry's magic mile. Eventually, the majestic arching branches, like Georgia's legacy oaks of President Wells, will offer both shade and solitude.

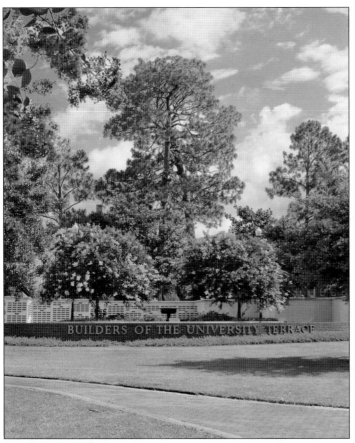

Near the first building erected on this hill in 1907 is a terrace at whose center a fountain flows gently. The idea behind this remarkable memorial is to remind each generation of its connection to the past. The Builders of the University Terrace, erected in the last decade of the 20th century, is a statement about individuals who spent their careers here as faculty, administrators, or staff members. Names are alphabetized according to one's year of retirement. Custodians and cooks appear alongside presidents and professors. The wall of the terrace honors all builders of the university.

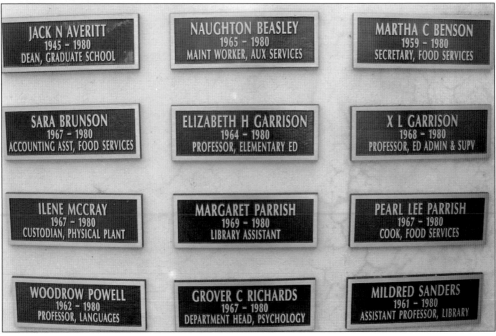

JACK N AVERITT
1945 – 1980
DEAN, GRADUATE SCHOOL

NAUGHTON BEASLEY
1965 – 1980
MAINT WORKER, AUX SERVICES

MARTHA C BENSON
1959 – 1980
SECRETARY, FOOD SERVICES

SARA BRUNSON
1967 – 1980
ACCOUNTING ASST, FOOD SERVICES

ELIZABETH H GARRISON
1964 – 1980
PROFESSOR, ELEMENTARY ED

X L GARRISON
1968 – 1980
PROFESSOR, ED ADMIN & SUPV

ILENE MCCRAY
1967 – 1980
CUSTODIAN, PHYSICAL PLANT

MARGARET PARRISH
1969 – 1980
LIBRARY ASSISTANT

PEARL LEE PARRISH
1967 – 1980
COOK, FOOD SERVICES

WOODROW POWELL
1962 – 1980
PROFESSOR, LANGUAGES

GROVER C RICHARDS
1967 – 1980
DEPARTMENT HEAD, PSYCHOLOGY

MILDRED SANDERS
1961 – 1980
ASSISTANT PROFESSOR, LIBRARY

Voices echo across the lakes and around Sweetheart Circle, beckoning all who have studied here to remember the past. Alumni who revisit may recall that they learned more than course subjects. It is here they opened, perhaps for the first time, the treasure of life that grows richer through all their years. The past lingers with the present among the pine, dogwood, oak, and willow trees. This is the university that endures.

DISCOVER THOUSANDS OF LOCAL HISTORY BOOKS FEATURING MILLIONS OF VINTAGE IMAGES

Arcadia Publishing, the leading local history publisher in the United States, is committed to making history accessible and meaningful through publishing books that celebrate and preserve the heritage of America's people and places.

Find more books like this at
www.arcadiapublishing.com

Search for your hometown history, your old stomping grounds, and even your favorite sports team.